The Campus History Series

SOUTHERN UNIVERSITY
LAW CENTER

The Campus History Series

SOUTHERN UNIVERSITY LAW CENTER

DR. RACHEL L. EMANUEL AND CARLA BALL
FOREWORD BY JUDGE FREDDIE PITCHER JR. (RET.)

ARCADIA
PUBLISHING

Published by Arcadia Publishing
Charleston, South Carolina

Printed in the United States of America

Library of Congress Control Number: 2017940851

For all general information, please contact Arcadia Publishing:
Telephone 843-853-2070
Fax 843-853-0044
E-mail sales@arcadiapublishing.com
For customer service and orders:
Toll-Free 1-888-313-2665

Visit us on the Internet at www.arcadiapublishing.com

This book is dedicated to all who believe in and practice seriousness of purpose.

CONTENTS

FOREWORD

Dr. Rachel Emanuel, author, researcher, historian, and 18-year employee of the Southern University Law Center, has once again produced a "must read" with this pictorial account of the founding, development, and progress of the Southern University Law Center (SULC). The story spans more than 70 years and ties the present-day law center to its humble beginnings and early struggles, from the days of a "separate but equal" doctrine that was rooted in the infamous 1896 *Plessy v. Ferguson* decision.

The courageous act of New Orleans native Charles J. Hatfield III, who in 1947 filed a lawsuit after being denied admission to the Louisiana State University Law School, produced a shift in history. The suit challenged the state's "separate but equal policy," and as a result, a new law school was established on the Southern University–Baton Rouge Campus. Dr. Emanuel and her colleague, Carla Ball, have done an excellent job of capturing the law center's progression through the compiled images of various contributing photographers.

Having matriculated at the law school first as a student, and then having returned as its sixth chief academic officer and chancellor, I can truly attest to the law center's transformation from an underfunded law school with 13 students, to a thriving institution of some 560 students. Its mission was and continues to be "providing access and opportunity" to students from all walks of life, and SULC is often cited as one of the most diverse law schools in the country. This pictorial history reveals how impactful this law center has been for its students, the State of Louisiana, the United States of America, and the world.

While our history started with the exclusion of Charles Hatfield III from obtaining a legal education within the State of Louisiana, 70 years later, we now celebrate inclusion and diversity. Our students have become leaders on the local, state, and national levels, serving as judges, legal scholars, private practitioners, and public servants—many of whom can be found in this book. I invite readers to learn of and be inspired by the achievements of all who have contributed to SULC's powerful legacy.

Thank you to the authors, advisory committee, and other contributors for their work in completing this pictorial history book. Through your efforts, our story is now brought to a greater audience.

—Judge Freddie Pitcher Jr. (Ret.)
Former SULC Chancellor (2003–2015)
Chancellor Emeritus (2017)

ACKNOWLEDGMENTS

We appreciate the foresight of Berryl Gordon-Thompson, Harold Isadore, and Gloria Simon for providing the nucleus of the Southern University Law Center photography collection (SULCPC). Unless otherwise noted, all images appear courtesy of the Southern University Law Center. Thank you to archivists and librarians Charlotte Henderson and Angela Proctor; Melissa Eastin and her exceptional staff; Miriam Childs; Barry Cowan; Bill Stafford; and Travis H. Williams for assistance with this effort.

We thank Arcadia Publishing for accepting the history as part of its Campus History Series. Caroline Anderson and David Mandel, always encouraging, guided us through the production process.

Most photographs are the works of professional photographers, including the late Simuel Austin, the late John H. Williams, Steve Jarreau, and N. John Oubre. Special thanks go to family members of major players in this story, including Charles Hatfield IV, Vanue B. Lacour Jr., Chanda M. Crutcher, and Bonnie C. Patterson Cannon, who provided photographs and shared stories for use in this book; advisory group members Danielle Bickham, Eugene Cicardo Jr., Felton DeRouen, Judge Ramona Emanuel, Angela Gaines, Harold Isadore, Frank Ransburg, Yvonne Schofield, Adrienne Shields, Claudette Smith-Brown, Gail Stephenson, and Evelyn Wilson; and those who assisted with photo identifications, including Judge Edwin Lombard, Raphael Cassimere, Henry P. Julien Jr., Bruce McConduit, Wanda Anderson Davis, Clyde Robinson, Gloria Moltrie, Norman Francis, and Phebe Poydras.

Thank you to the individuals interviewed, as well as the authors of books and other written materials, who provided editorial information for photograph captions, including the late professor Clyde Tidwell, whose book, *A History of Southern University School of Law as Reflected in its Bulletins, 1947–1997*, was a tremendous resource.

To Chancellor John K. Pierre and other individuals who expressed appreciation for the work we were pursuing, we are truly grateful. Lastly, thank you Lawryn Owens, Judge Leon L. Emanuel, Ken and Regina Martin, and Jim and Dorothy Kelly for reinforcement.

Names of organizations are abbreviated in the text and courtesy lines as follows: American Bar Association (ABA), Historically Black Colleges and Universities (HBCU), Louisiana State Bar Association (LSBA), National Association for the Advancement of Colored People (NAACP), NAACP Legal Defense and Educational Fund (LDF), and Southern University Law Center (SULC).

INTRODUCTION

Louisiana established Southern University in 1880 as the separate land-grant college for persons of color 15 years after the end of the Civil War. In 1888, Southern was authorized to establish a law department and medicine department. However, it was not until January 10, 1947, that plans were approved and funding was provided for the law school at Southern.

The Southern University Law School began its first year in the fall semester of 1947.

The initial school mission was to train a cadre of lawyers to be equipped with the skills necessary for the practice of law and for positions of leadership in society. The school awarded its first degrees to six students in June 1950. Using their legal training, members of each graduating class of the law school set forth to be lawyer-leaders. Whether they are participating in organized demonstrations or creating change working within the legal system, one step at a time they seek and achieve some measure of equality, civil rights, and justice.

After 38 years of operation as a law school, the Southern University Board of Supervisors re-designated the school as the Southern University Law Center in 1986.

The current mission is "To provide access and opportunity to a diverse group of students from underrepresented racial, ethnic, and socioeconomic groups to obtain a high quality legal education with special emphasis on the Louisiana civil law." Consistent with the rich heritage of the Southern University System, the law center has stressed legal education of high quality for qualified students from diverse backgrounds.

Accredited by the American Bar Association, the American Association of Law Schools and the Commission on Colleges of the Southern Association of Colleges and Schools, SULC prides itself on being one of the most affordable law schools in the country. It ranks number one in faculty diversity.

Law center faculty, staff, and alumni have been willing to tell their stories to each generation of law students and their peers. Likewise, the accomplishments of the law center's alumni, faculty, staff, and students are highlighted in a continuing effort to keep the Southern University Law Center in the forefront as an institution that has made positive change. It continues to provide leadership in advancing of justice and human rights. This publication shares a glimpse into its glorious past and reveals a continuing commitment for the best in the future.

One

A COURAGEOUS ACT
CATALYST FOR CREATION OF A
LAW SCHOOL FOR PEOPLE OF COLOR

New Orleanian Charles J. Hatfield III wrote a letter on January 10, 1946, to the university's registrar seeking admission to the Louisiana State University Law School. That letter and Hatfield's subsequent lawsuit against LSU were audacious and courageous acts—the catalyst for creating the Southern University Law School. Although he did not gain entry to law school, his actions paved the way for African Americans and others to obtain a legal education. (Courtesy of Charles J. Hatfield IV.)

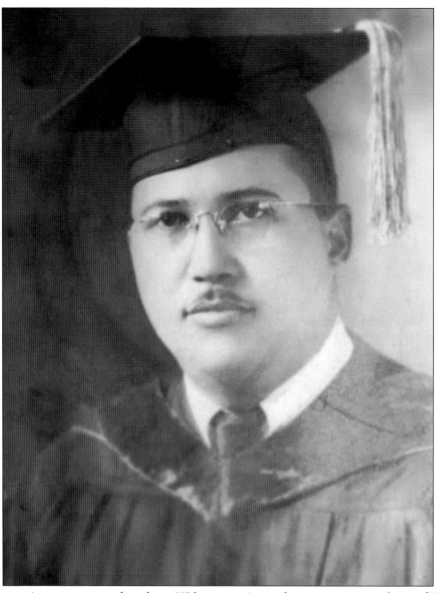

As a returning veteran, employed as a US letter carrier, and a prospective graduate of Xavier University of New Orleans, Hatfield met all requirements for admission to the LSU Law School, except that he was not white. After notification that LSU would not accept him, he applied to Southern University, knowing that the historically black institution did not have a law program. Hatfield earned a B.A. in history, Spanish, and English from Xavier University in 1946. He accepted an offer of admission to Atlanta University in Georgia, where he earned a master's degree in sociology in 1948. In 1950, he was offered a full scholarship to Loyola University Law School in New Orleans; however, he declined the offer because of family financial obligations. He was an educator in New Orleans public schools from 1953 to 1979, labor activist in the American Federation of Teachers Local No. 527 and American Federation of Labor and Congress of Industrial Organizations (AFL/CIO) Greater New Orleans Council, and founding member and field representative for United Teachers of New Orleans from 1954 to 1972. (Courtesy of Charles J. Hatfield IV.)

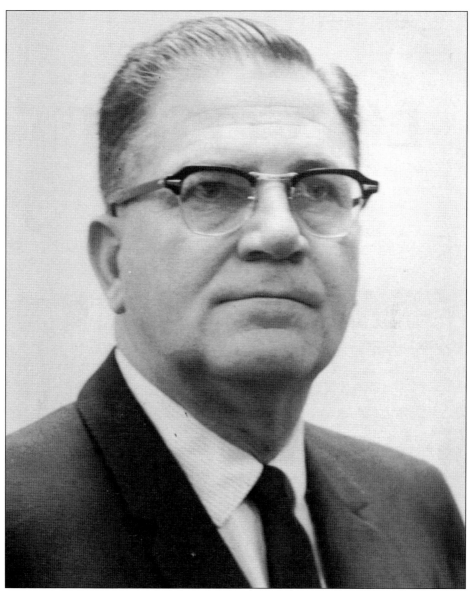

In a letter dated January 24, 1946, LSU Law School dean Paul M. Hebert advised Hatfield of the following: "Louisiana State University does not admit colored students." Hebert, the longest-serving dean of the LSU Law School, served—with brief interruptions—from 1937 until his death in 1977. One of these interruptions occurred shortly after the SU Law School was established when Hebert was appointed as a judge for the US Military Tribunals in Nuremberg. The Baton Rouge native earned a bachelor of arts and bachelor of laws degrees from LSU and won a Sterling Fellowship at the Yale Law School, where he earned his doctorate of juridical science in 1930. He served on the faculty at the Loyola Law School for one year before joining the law faculty at his alma mater in 1931. The following 1932–1933 school year, he returned to Loyola as dean and professor. In fall 1936, Hebert returned to LSU to serve as dean of administration and professor of law. The LSU law dean has been described as building the school's national image while also cementing relations with the Louisiana bar. (Courtesy of Louisiana State University Law Library Archival Collections.)

copy

Louisiana State University

Law School

Baton Rouge, Louisiana

24 January 1946

Charles J. Harfield, III,
663 N. Prieur Street,
New Orleans, Louisiana

Dear Sir:

Your letter of January 10, 1946, wherein you expressed
an interest in making application for admission to the Law
School of Louisiana State University this summer, has been
referred to this office for reply.

As you know, the State of Louisiana maintains
separate schools for its white and colored students. Louisiana
State University does not admit colored students. Southern
University, located at Scotlandville in East Baton Rouge Parish,
Louisiana, is the principal Louisiana university for negroes.
That University is governed by its own Board of Trustees and
is under the supervision of the State Department of Education;
and, the State of Louisiana has authorized that University to
establish and maintain a department of law.

Very truly yours,

Paul M. Hebert
Dean

PMH:fm

At the time Hebert responded to Hatfield, Louisiana was under the de jure system of "separate but equal" prohibiting black and white students from being formally educated together. Dean Hebert was chosen to draft a plan for the law school at Southern. His plan was aimed at satisfying the requirements of the American Bar Association and the American Association of Law Schools. (Courtesy of Amistad Research Center, Tulane University/A.P. Tureaud Papers.)

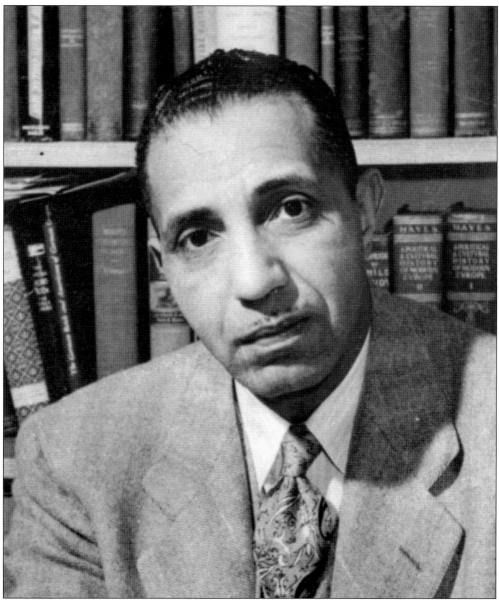

Succeeding his father, Dr. Joseph Samuel Clark, Dr. Felton Grandison (F.G.) Clark was the second president of Southern University and A&M College after it was relocated to Scotlandville in 1914. In her book, *Laws, Customs and Rights: Charles Hatfield and His Family, a Louisiana History*, Evelyn L. Wilson wrote, "He protected the school from its detractors, inside and out, and worked strategically to guarantee its continued funding. Smooth and articulate, Clark was a racial diplomat who ensured the survival and controlled the future of his school." In 1943, he was chairperson of a Baton Rouge group, organized by another Louisiana educator, J.K. Haynes, to demand that the state provide graduate educational opportunities for the state's black residents. Dr. Clark's reply to Hatfield's letter of application to Southern was that "Southern University does not have a law school." He added, "My feeling is that . . . Louisiana might soon provide out-of-state tuition subsidies as several of the other progressive southern states are now doing." (Courtesy of Southern University Archives/John B. Cade Library.)

Southern University

F. G. Clark, President

Scotlandville, Louisiana

February 15, 1948

Mr. Charles J. Hatfield
563 N. Prieur Street
New Orleans, Louisiana

Dear Mr. Hatfield:

I am acknowledging your letter of January 26, in which you apply to Southern University "for admission to the Department of Law."

Southern University does not have a Law School. For your information, I might state that at the last session of the Legislature, a Bill was introduced, under the sponsorship of the State Board of Education, designed to provide funds for scholarship subsidies to Negro citizens which would enable them to obtain out-of-state graduate and professional education based upon in-state facilities for white citizens. It happens that that the Bill was vetoed because it was felt that state funds were not available to finance it.

Much interest is being given this whole matter of providing for the professional education of Negroes in the State at the present time. Because of this, my feeling is that very probably Louisiana might soon provide out-of-state tuition subsidies as several of the other progressive southern states are now doing and have been doing for several years.

Sincerely yours,

F. G. Clark,
President.

cc: Governor Jimmie H. Davis
Superintendent John E. Coxe
Honorable George T. Madison
Mr. Joseph E. Gibson

Dr. Clark's reply to Hatfield was optimistic regarding the possibility of Louisiana providing out-of-state tuition subsidies to black residents seeking educational opportunities in graduate and professional schools. Hatfield knew that the legislation Clark anticipated would establish a program declared inadequate and unconstitutional by the US Supreme Court eight years earlier in *Missouri ex rel. Gaines v. Canada*. He sought the legal assistance of his friend, New Orleans civil rights attorney Alexander Pierre (A.P.) Tureaud, to represent him in a lawsuit to allow his admission into LSU. (Courtesy of Amistad Research Center, Tulane University/A.P. Tureaud Papers.)

After accepting Charles Hatfield's case, New Orleans civil rights attorney A.P. Tureaud asked Thurgood Marshall (both pictured at right, from left to right), then special counsel for the NAACP LDF, and Louis Berry (pictured below), a law professor at Howard University in Washington, DC, to act as co-counsel. On October 10, 1946, Berry, Marshall, and Tureaud filed Hatfield's suit against the LSU Board of Supervisors, LSU president W.B. Hatcher, and LSU Law School dean Paul M. Hebert. Two weeks earlier, the trio had filed on behalf of Viola M. Johnson, who wanted to attend LSU's Medical School. Marshall and Tureaud were longtime colleagues, as Tureaud was the participating attorney for Louisiana on civil rights cases litigated in the state of Louisiana from 1927 through the 1960s. (Right, courtesy of Barcroft Media; below, courtesy of the A.A. Lenoir family.)

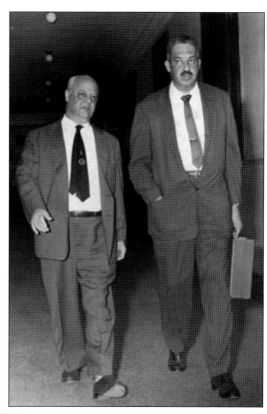

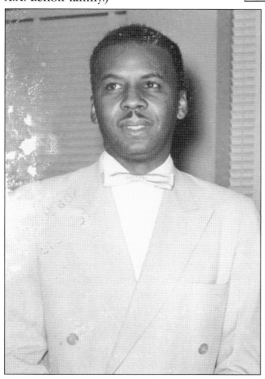

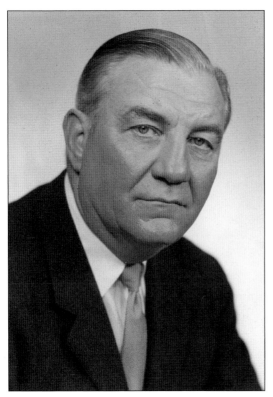

The Louisiana State Board of Education approved plans for the law school in January 1947. In May, Judge G. Caldwell Herget dismissed Hatfield's case, accepting the argument that the mandamus should be issued against Southern, not LSU. The judge (left) noted that the legislative act creating Southern permitted the university to establish law and medical departments and was convinced the act imposed a mandatory duty on the SU Board to do so. Southern had not been made a party to the lawsuit, so a mandamus could not be issued against the university. State superintendent of education John E. Coxe (below) addressed the 1948 SU commencement. He praised the work done by SU and told the 75 graduates, "You have demonstrated that you are trustworthy . . . you will be depended upon to carry on for your race and for civilization." (Left, courtesy of the Baton Rouge Chamber; below, courtesy of the Louisiana State Archives.)

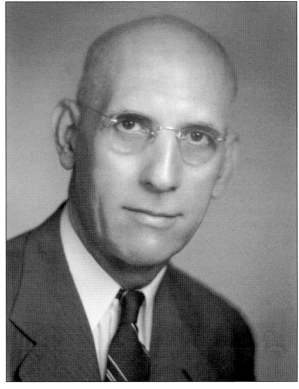

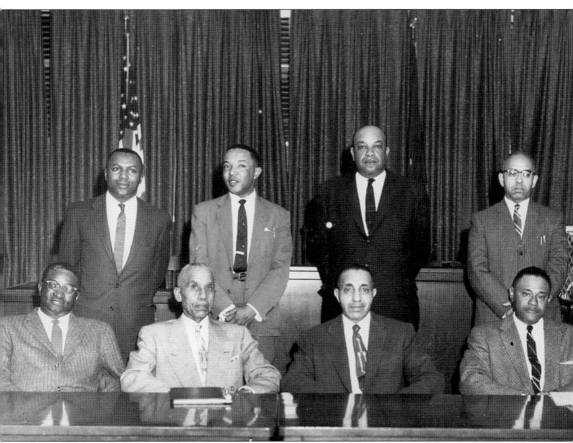

A law school was organized at Southern University with an initial budget of $40,000. DeRidder, Louisiana, native Aguinaldo Alphonso (A.A.) Lenoir, who was first appointed acting law school dean, and other administrators at Southern firmly believed that it was only by greatly increasing the number of black lawyers in America that black people would achieve social justice and racial equality in the South and the rest of the country. Serving from 1947 to 1970, Dean Lenoir worked with administrative leaders, educators, community supporters, alumni, friends, and family to provide law students with the tools they needed to practice law and succeed as legal practitioners. His first faculty members were Thomas Sebastian Earl Brown, Vanue B. Lacour, and Edward L. Patterson; and the first law librarian was C. Vernette Grimes. Pictured from left to right are SU administrators and faculty members (seated) J. Warren Lee (biology), James Blaine Moore (industrial arts), SU president Felton G. Clark, and Wallace Bradford (School for the Deaf); (standing) Burnett A. Little (auditor), Lenoir, Benjamin Kraft (security), and Russell Amphey (biology).

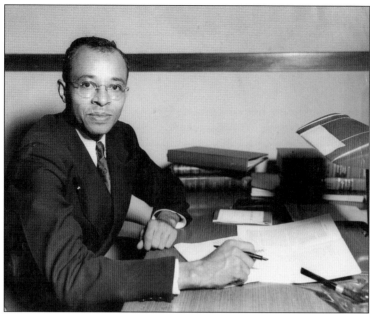

Vanue B. Lacour joined Southern's first law faculty. Throughout his 24-year tenure, Lacour embraced Lenoir's vision of creating legal professionals that would assist in achieving racial equality. "When I came to the law school, I believed I was fighting my way out of a job, because we would defeat segregation and there would be no more Jim Crow schools," he said.

Tuskegee, Alabama, native Edward L. Patterson Jr. earned a bachelor of science from Tuskegee Institute, bachelor of laws from Lincoln University School of Law, and master of arts from University of Chicago before coming to Louisiana's new law school. Patterson taught Family Law and Torts, a five-hour course with instruction for two hours on Mondays and one hour Tuesday through Friday. He required law students to adhere to a strict dress code. Patterson died in 1968, and SULC's moot courtroom is named for him. (Courtesy of Bonnie C. Patterson Cannon.)

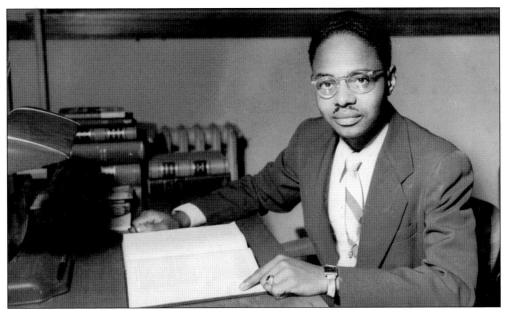

First SU law faculty member Thomas S.E. Brown, of St. Louis, Missouri, was a graduate of Harvard Law School. Brown earned a bachelor of arts from Lincoln University. Initially assigned to teach Torts I and II; Legal Bibliography and Brief Making; Legislative and Administrative Organizations and Procedure; Business Organization; and Criminal Procedure, he later taught Legal Bibliography; Criminal Procedure; Sales and Real Estate Transactions; and Successions, Donations and Community Property. Chancellor emeritus B.K. Agnihotri believed that Professor Brown had outstanding qualifications and could have taught at almost any law school in the country but came to Southern because of his commitment to providing access and opportunity to black students interested in pursuing a legal education. According to a former student, Brown taught Successions, Donations and Community Property with "gusto" that made him want to go out and provide legal representation to clients in the community that he knew were in much need of such services.

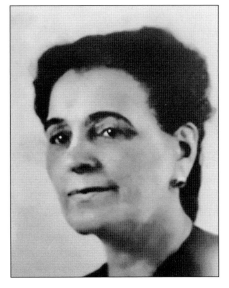

SULC's first law librarian, C. Vernette Grimes, was admitted to the Tennessee Bar in 1938. A native of Muskogee, Oklahoma, Grimes earned a BA from Fisk University, a BS from Tennessee State College, and an LLB from Kent College of Law in Chicago. Formerly an assistant dean of women at Fisk University, she transferred to Southern as dean of women in 1945. Interviewed for a feature in *Ebony* magazine, she said, "There is a definite need for women lawyers." She expressed pride in the fact that at Southern, she had discovered three young women possessing what she believed to be the qualities for successful law study. (Courtesy of Southern University Archives/John B. Cade Library.)

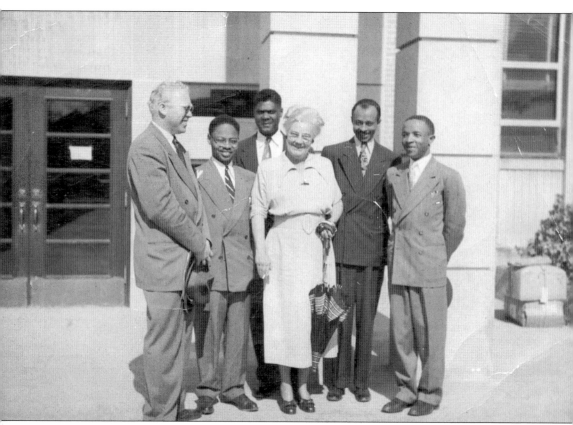

The original SU law faculty members, pictured here from left to right, Edward L. Patterson and Thomas S.E. Brown and (fifth and last) Vanue B. Lacour and Dean A.A. Lenoir, were not only law instructors and mentors to their students but also the school's ambassadors and institutional advancement officers to those outside the law school. These individuals have gone down triumphantly in the annals of legal education for their ability to advocate for the historically black law school and its important role among legal education institutions. They have proven its value to the legal practice and those who need legal services. (Courtesy of Southern University Archives/John B. Cade Library.)

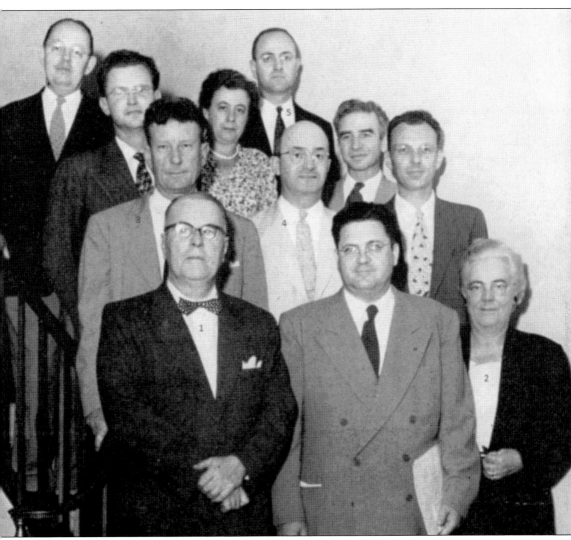

Under the plan for the establishment of Southern's law school approved by the Louisiana State Board of Education, members of LSU's law faculty would teach Louisiana civil law at the new school. Black students barred from Louisiana law schools had not studied the required civil law curriculum, so the LSU faculty was also responsible for training Southern's first law professors in the civil law. Southern's first-year adjunct professors included LSU professors (1: first row, left) Henry McMahon, who earned an AB, LLB, and AM from LSU; (2: first row, right) Harriet Spiller Daggett, who earned a BA, MA, and LLB from LSU; (3: second row, left) J. Denson Smith, who earned an LLB from LSU and a JD from Yale University School of Law; (4: second row, center) Joseph Dainow, BA, BCL, McGill University, Doctorate in Law, University of Dijon, and SJD, Northwestern University; and (5: fourth row, right) Robert A. Pascal, BA, JD, Loyola University, New Orleans; MCL, LSU, and LLM, University of Michigan. Not pictured are Alvin Rubin and Wallace Hunter. (Courtesy of LSU Special Collections/Gumbo, 1953).

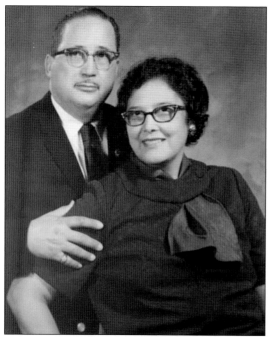

The 30-year-old Charles Hatfield, married with two children, knew that bringing a lawsuit to desegregate the LSU law school was dangerous. He endured threatening phone calls to his home, verbal abuse at his job, and a close call with the potential for bodily harm after meeting a stranger offering him money if he dropped the lawsuit. His wife, Beulah (pictured with Charles at left), and mother, Mary, did the worrying for the family during that time. (Courtesy of Charles J. Hatfield IV.)

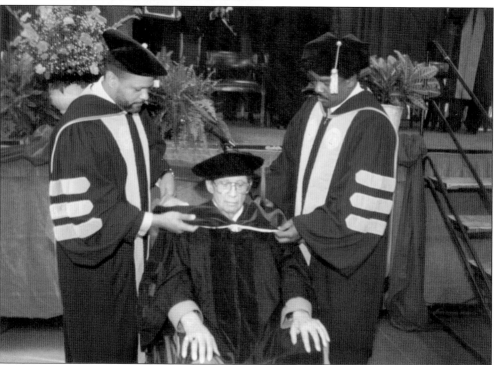

In 2002, a month before his death at the age of 87, Hatfield received the first honorary juris doctorate awarded by SULC. SU Board of Supervisors members John F.K. Belton (left), class of 1990, and Antonio "Tony" Clayton (right), class of 1991, participate in hooding Hatfield during the SULC commencement. There would be other law center tributes to Hatfield and his legacy, and he is honored by each generation of law graduates.

Two

LEADERSHIP
ADMINISTRATION AND STAFF

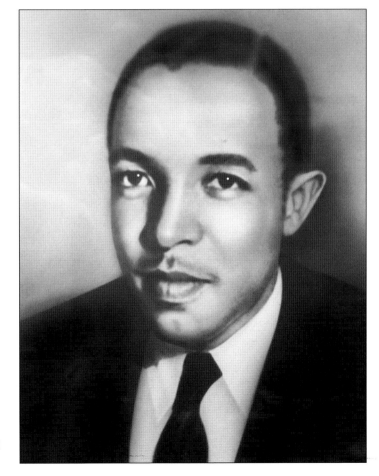

Southern's first law dean, A.A. Lenoir, was a 1939 graduate of Xavier University in New Orleans and a 1942 graduate of Lincoln University Law School in Missouri. He had the arduous task of creating a "separate, but equal" institution for African Americans to pursue a legal education in his native state of Louisiana. Lenoir dedicated 23 years to the school and this task.

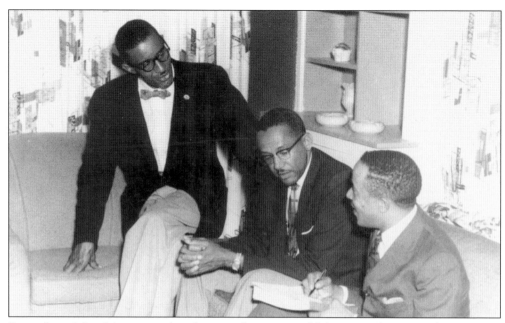

Dean Lenoir's vision was that law graduates would become firsts in their career attainments and one step at a time would achieve some measure of equality, civil rights, and justice. Lenoir found opportunities very limited when he completed his legal studies in 1942. He first worked as a foreman at the US Cartridge Plant in St. Louis and taught political science at Lincoln University. After a brief stint in the US Army, he was offered a position as acting dean at Louisiana's newly created law school. Faced with dismal funding, Lenoir (above, seated at far right) persevered, showing the education and legal communities that there was little need to doubt the value of educating any segment of the population. Lenoir died in Washington, DC, in 1971, at the age of 52. Children and grandchildren of Lenoir and his wife, Estella, attended a program in the dean's honor held at the law center. Pictured below are, from left to right, (first row) Ashley and Josh Hudson; (second row) unidentified, Iyanna Sterling, Ruth LeNoir [*sic*] Hudson, Lenita Lenoir, and unidentified.

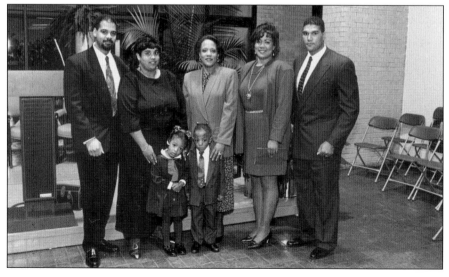

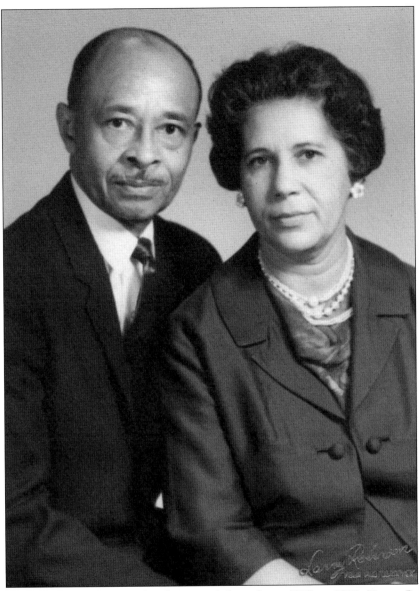

During his tenure as the law school's second dean from 1970 to 1971, Vanue B. Lacour of Cane River, Louisiana, placed emphasis on faculty and student legal scholarship. A noted legal scholar, Lacour was valedictorian of his 1933 high school class, summa cum laude 1938 graduate of Xavier, and salutatorian of his 1941 Howard University Law School class. He practiced law in St. Louis, Missouri, for a brief time before accepting the call to return to Louisiana and serve on Southern's law faculty. As a lawyer, he almost single-handedly changed the succession and forced heirship laws in Louisiana. One of his most famous cases was *Weber v. Aetna Casualty & Surety Co.* The US Supreme Court in 1972 held that "Louisiana's denial of equal recovery rights [under workers' compensation statutes] to dependent unacknowledged illegitimates violates the Equal Protection Clause of the Fourteenth Amendment." Lacour; his wife, Arthemise Wilson Lacour; and their seven children lived in Scotlandville's Southern Heights subdivision near the Southern University campus. (Courtesy of Vanue B. Lacour Jr.)

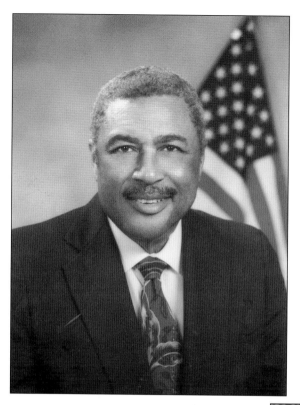

Jesse Nealand Stone Jr., a native of Gibsland, Louisiana, served as dean from 1971 to 1972. One of the school's first graduates, Stone focused the program of instruction on flexibility to meet the varied needs of the students and curriculum revisions to involve testing the rule of law in solving societal problems. Southern's third law dean was later called the "Bridge Builder" for his ability to build relationship between the races during his tenure as a public servant and legal practitioner.

Jesse N. Stone Jr., class of 1950, opened his law office in Shreveport, Louisiana, in 1950 becoming a criminal law attorney and active in the civil rights movement. Stone was initially required to practice behind the rails in the segregated courtrooms of north Louisiana. He broke color barriers in Louisiana when he was appointed associate director of the Louisiana Commission on Human Relations, Rights and Responsibilities, as assistant state superintendent of education, and as the first African American appointed to the Louisiana Supreme Court, serving as associate justice pro tempore. He was the first SULC graduate to serve as dean of his law school alma mater and was the first president of the Southern University System. In 1985, he became an SULC law professor, retiring in 1986. He was a member of the Southern University System Board of Supervisors from 1991 to 1995. He is pictured with wife, Willa Dean Anderson Stone (standing left), a state educator; and his daughter, Shonda Stone (standing right, see page 100).

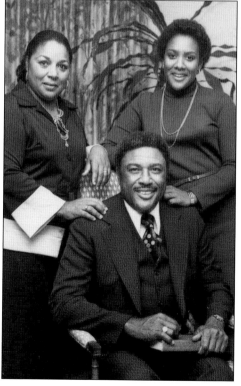

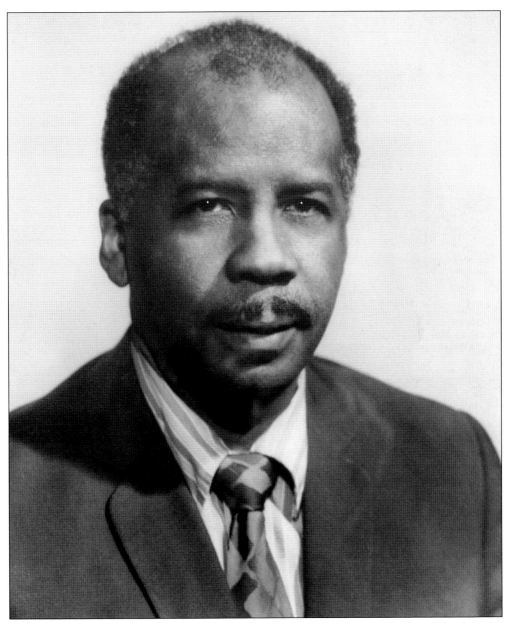

Louis Berry, law dean from 1972 to 1974, initiated the "seriousness of purpose" axiom for law students. In August 1945, Berry became the first African American admitted to the practice of law in Louisiana since 1927. Criminal defense lawyer Camille Gravel gave Berry the customary introduction to the Alexandria Bar Association in 1945, when other white attorneys refused to do so. "It was one of the greatest thrills of my life to be involved in a [higher education law] suit against the state where I was barred from studying law," Berry said of his desegregation litigation. Attributing much of the improvement of black life in the city to his activism, the *Alexandria Daily Town Talk* quoted Berry as having said, "Young people will be surprised to know the conditions under which blacks had to exist at the time, for they really had no rights that anybody was bound to respect." He was the father of two daughters: Patricia Berry Arceneaux and Elvina Yvette Calland.

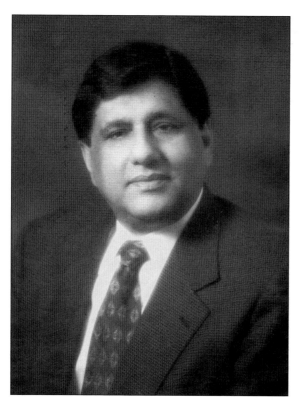

Bhishma K. Agnihotri served as dean/chancellor from 1974 to 2001. Agnihotri was the only Indian in the history of the American legal system to head an American law school. At the time he retired, he had served for 26 years, half the life of the school. Beginning his career in India as a judge, Agnihotri came to America for higher studies and earned two advanced degrees in law from University of California, Los Angeles, and New York University. He developed and expanded facilities, programs, faculty, staff, and the student body. He strengthened alumni ties and weathered challenges to the school's ABA accreditation. The chancellor emeritus said, "This school became politically indispensable to the state as the institution was well represented in the legislature and the judiciary." He is pictured below with his wife, Krishna, who served on the SU faculty.

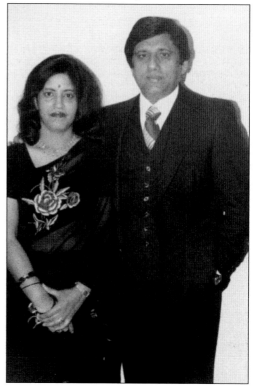

Retired judge Freddie Pitcher Jr. (right), chancellor from 2002 to 2015, earned a bachelor of science and juris doctorate from Southern. Because of the excellent legal education he received at Southern, the Baton Rouge native said he became the first African American elected to a Baton Rouge judgeship in a citywide election to city court in 1983; elected to the 19th Judicial District Court in a parish-wide election in 1987; and elected to the Louisiana First Circuit Court of Appeal in 1992. Pitcher also served as a Louisiana Supreme Court associate justice ad hoc. He was named a partner with the Baton Rouge office of Phelps Dunbar, LLP, upon his retirement from the bench in 1997. Formerly a principal partner in the firm Pitcher, Tyson, Avery, and Cunningham, he has served as a special counsel to the Louisiana attorney general and as an assistant district attorney of East Baton Rouge Parish. Chancellor emeritus Pitcher and his wife, retired SU professor Harriet Pitcher, are pictured below. They have one daughter, Kyla D. Pitcher. (Right, courtesy of Phelps Dunbar, LLP.)

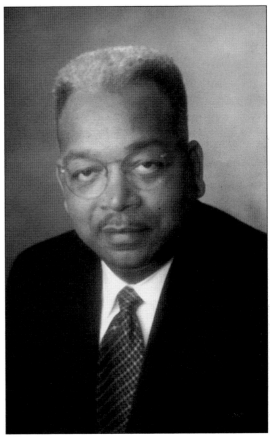

John K. Pierre was appointed chancellor in 2016, becoming the seventh individual to head the institution. Pierre joined the law faculty in 1990 and was promoted to associate vice chancellor for special projects in 2003 and to vice chancellor of institutional accountability and evening division in 2006. He teaches Commercial Law, Tax Law, Contracts, and Property. He earned a bachelor of science in accounting from Southern in 1980, master of science in tax accounting from Texas Tech University in 1982, and the juris doctorate from the Southern Methodist University, Dedman School of Law, in 1985. As a practitioner, Pierre was co-counsel in the Baton Rouge school desegregation case, *Davis v. East Baton Rouge Parish School Board*, and in the landmark case of *McWaters v. FEMA*. The Loreauville, Louisiana, native is thankful for the support of his wife, Antoinette; his mentors, chancellor emeritus B.K. Agnihotri and Judge Freddie Pitcher Jr. (ret.); and the team of SULC faculty and administrative staff. Pictured at left are Chancellor Pierre and his wife, Antoinette Pierre, retired principal, East Baton Rouge Parish Schools.

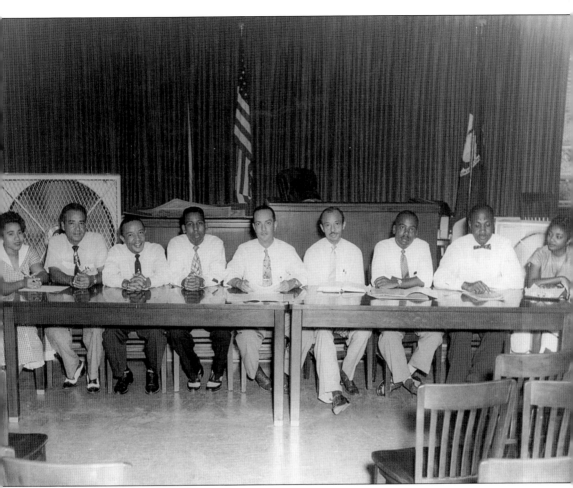

The first issue of the law school bulletin stated the following: "Its primary objective is the training of qualified men and women for the practice of law in Louisiana where the civil law system prevails." Tuition was free for all Louisiana residents. Fees included $25.50 general and a $10 per semester law library fee. Nonresident students were charged on a reciprocal basis. The school was granted provisional approval by the American Bar Association in 1952 for the law school's three-year curriculum and the combined curriculum in arts and sciences and law. The school actively recruited veterans of World War II. Upon favorable faculty recommendation, the bachelor of laws degree was awarded to students who successfully completed all curricula requirements. Law faculty worked closely with SU faculty in the political science, education, and other disciplines, where students matriculated before entering law studies. Pictured from left to right are Betty Scott George, business office; Rodney G. Higgins, political science; A.A. Lenoir; Twiley Barker, political science; William W. Clem, education; Vanue B. Lacour; Lucius Barker, political science; Lewis White, biology; and Dorothy Baston.

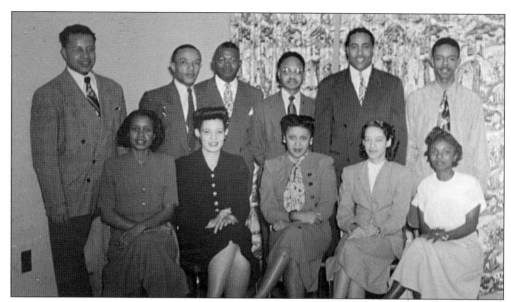

The law faculty had increased to seven full-time members by 1953. In addition to this administrative work, Dean Lenoir taught courses in Civil Law Property, Common Law Property, Criminal Law, and Agency and Security Devices. The dean enjoyed socializing and discussing the law with fellow faculty and their spouses, students, and other members in the community. (Courtesy of the A.A. Lenoir family.)

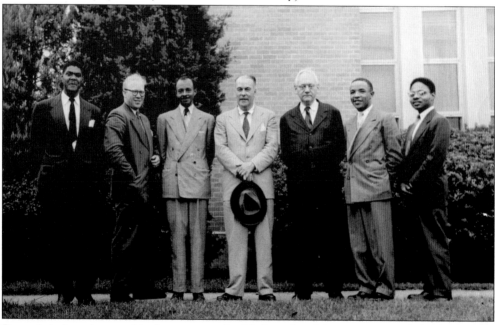

Dean A.A. Lenoir was deeply concerned with how legal institutions and the law could be used to create a more just and better society. He and his faculty believed that their students would make sweeping changes in Louisiana and other Southern states. SULC faculty members are pictured with guests to the campus. Standing second from left are Edward L. Patterson and Vanue B. Lacour. Second from right is Dean Lenoir, and at far right is Thomas S.E. Brown. (Courtesy of Bonnie C. Patterson Cannon.)

Oliver B. Spellman (above) was named law librarian in the 1953 to 1954 academic year, succeeding C. Vernette Grimes, Marcia M. Fenelon, and George Strait (acting). Spellman, who earned a law degree from the Brooklyn Law School, became a full-time faculty member in 1956. He died during his tenure in 1964. The Louis A. Martinet Legal Society Student Loan Fund was renamed the Oliver B. Spellman Memorial Student Loan Fund, and the SULC Law Library was named in his honor. George A. Lawson succeeded Spellman as law librarian. However, he joined the law faculty the next school year (1957–1958), teaching a seminar in legal writing.

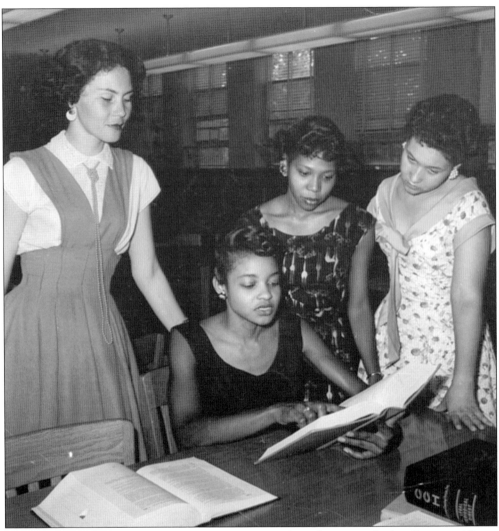

Law librarian Mary Gloria Wilson Lawson, class of 1956, was undoubtedly a significant role model for females seeking a law degree at Southern. Wilson joined the Southern administrative staff as law librarian shortly after becoming the first African American woman admitted to the Louisiana bar. She served until the 1961–1962 school year. Despite a small budget and an un-air-conditioned facility, under her tenure the collection grew from 20,000 to approximately 25,000 volumes, and Hillary Brown was hired as an assistant law librarian. Lawson returned to the school as coordinator of placement and continuing legal education during the 1976 to 1977 school term. Her significance as a first has been recognized by the bar and bench. She was one of the "First 100 Women Lawyers in New Orleans" honored in 2014 by the New Orleans Bar Association's Women in the Profession Committee. Lawson, pictured seated, was also one of the female lawyers featured in an exhibit at the Supreme Court of Louisiana in 2015. (Courtesy of the SULC Alumni Association.)

Other law librarians hired at the law school during the 1960s were Gwendolyn Crockett, class of 1958; Beverly Allen; Melbarose Manuel (pictured at right); and Clyde C. Tidwell, class of 1966. Manuel served from 1966 to 1989, with four deans as assistant law librarian, acting librarian, associate librarian, or law librarian. At her departure, the library had a seven-member full-time staff and its collection had approximately 296,960 volumes, including a subscription to a computerized legal research system.

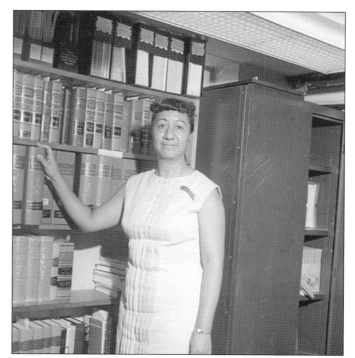

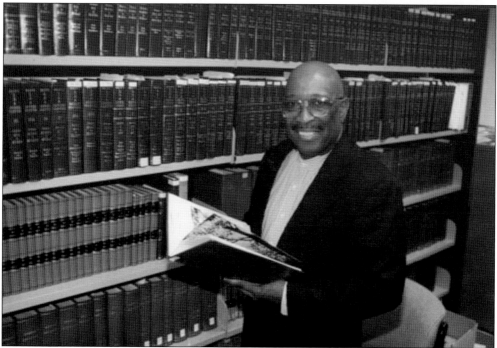

SU graduate Clyde C. Tidwell (pictured) was employed first as a law librarian from 1969 to 1970. He was appointed to the law faculty and served in both positions until 1978, when he was assigned to the faculty exclusively. Tidwell's name is synonymous with legal research. However, other courses he taught included Civil Law Property, Professional Responsibility, and Criminal Law.

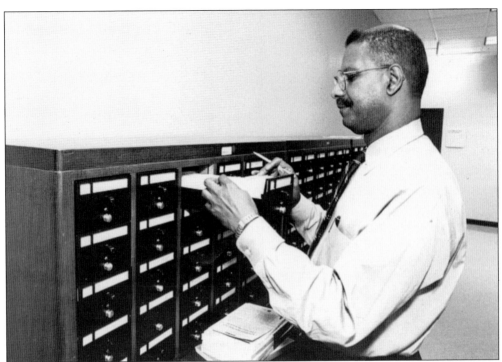

Succeeding Tidwell were Yvonne Fonville, who served from 1978 to 1980, and Ann S. Jones, who served from 1980 to 1981. Harold Isadore (pictured above), class of 1970, joined the SULC administrative staff as assistant librarian in 1975 and was promoted to associate law librarian in 1985. The Alexandria, Louisiana, native was a valuable asset to the faculty and administration because of his research skills. He retired as acting director of law library services in 2015. Pictured below from left to right are library staff members (sitting) Pinki Diwan, Melbarose Manuel, and Rosland Lacour; (standing) Enella Kelly, Christine Nappier, Anna Bibbs, Harold Isadore, and Ollie Lewis.

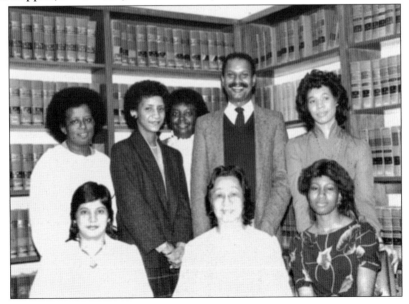

A member of the SU class of 1970, Alvin Roché earned a master of science degree in library science from LSU in 1972. The New Orleans native joined the SULC library staff in 1985 as an associate law librarian. From 1988 to 2007, Roché served as the director of law library services, supervising 18 employees and 20 student assistants. He retired in 2007. The library reference room is named in his honor.

Ruth Hill was director of law library services and a faculty member from 2007 until her death in 2015. The Austin, Texas, native earned an MSLS from the University of Memphis and a JD from the University of Tennessee at Knoxville. Professor Hill earned tenure at SULC. She previously held positions in law libraries and on law faculties at Loyola Law School, Los Angeles, California; Howard University School of Law in Washington, DC; and University of Tennessee College of Law in Knoxville. Two SULC scholarships have been established in her name by her husband, the Rev. Charles Peters.

Gloria S. Simon, who joined the law school staff in 1972 as secretary, was named administrative assistant to the dean with the departure of Dorothy Baston, in 1977. Baston had served the law school as secretary and administrative assistant to the dean since 1949. Simon, a 1962 SU graduate, earned a bachelor's degree in business education and 26 hours in guidance counseling in graduate school. She joined the law school staff after several teaching and administrative positions in the public schools of East Baton Rouge and Livingston parishes. Her duties included typing for the nine faculty members, preparing the payroll, admitting students, answering the telephone, and forwarding messages. Retired after 35 years, the executive assistant to the chancellor described her tenure with three chancellors Louis Berry, B.K. Agnihotri, and Freddie Pitcher Jr. as enjoyable and rewarding. Simon also said, "I enjoyed the relationship I had with the students. I was able to meet parents, while preparing for graduation and other functions. Today, I meet former students and they thank me repeatedly for their success." Simon is pictured with law graduate Judge Angelo Piazza of Marksville, Louisiana. (Courtesy of Judge Angelo J. Piazza III.)

Secretarial and clerical staff members were added as the number of law school administrators and faculty increased, particularly in the 1960s, 1970s, and 1980s. Their names include Harrietta Bridges, class of 1986; Minnie J. Daniel; Ray Helen Jones; Drusilla King; and Juanita Richard. Pictured from left to right are (sitting) Helen Burris; Anna Richard; Yvonne Williams Schofield; Gloria Simon; and Carol Sept; (standing) Gloria Mann; Lucius Thomas, class of 1984 (director of placement); and Blanche Lightell.

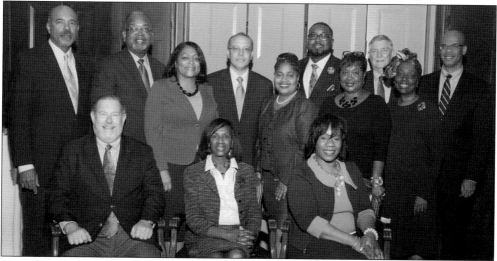

The law school's educational environment is enhanced because of the good relationships SULC administrators and faculty members maintain with leaders in legal professional organizations throughout the state and nation. Many also have become leaders in these organizations. In 2014, SULC hosted a reception honoring the ABA president-elect Paulette Brown. Pictured from left to right are (seated) LSBA president Joseph L. "Larry" Shea; Paulette Brown; and Pamela J. Meanes, NBA president; (standing) SU System president Ronald Mason Jr.; Chancellor Freddie Pitcher Jr.; Judge Yvette Alexander, chair of the Wiley A. Branton Awards Committee; BRBA president Darrel Papillion; Cynthia Reed, class of 1990, SULC director of CLE and alumni affairs; Christopher Hebert, class of 2003, NBA Region 6 chair; SU System general counsel Tracie Woods; LSBA immediate past president Richard Leefe; Ruth Bailey Wesley, class of 1993, SULC executive assistant to the chancellor; and SU Alumni Federation president Preston Castille.

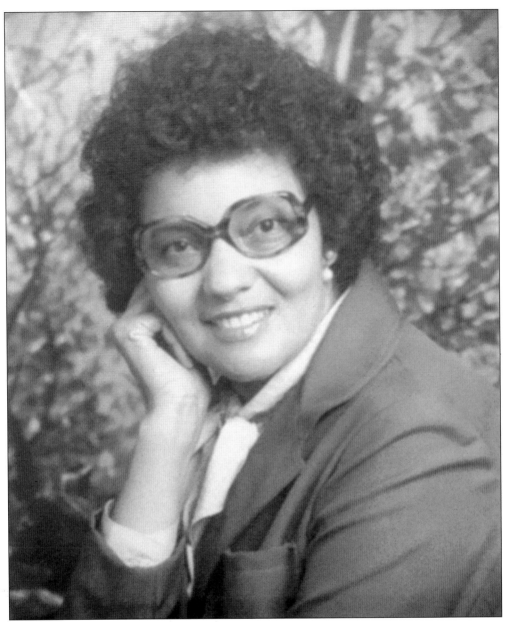

During the years of Chancellor Agnihotri's tenure and beyond, administrative positions were added. Many were required for accreditation purposes and, after 1985, when the school was re-designated as a law center. New administrators provided needed services for law students, and they and their growing staff members became intricately a part of the law school experience. Jackie Marie Scott, class of 1977, became coordinator of placement and continuing legal education. Winstonia Smith (pictured above), a native of Tucson, Arizona, and longtime resident of Baton Rouge, became director of admissions at the law center in 1976. She had worked in the SU Registrar's Office since October 1956. Her family members established a scholarship for students in graduate and professional schools at Shiloh Missionary Baptist Church in her name because she expressed the students' need for financial assistance. (Courtesy of the Smith family.)

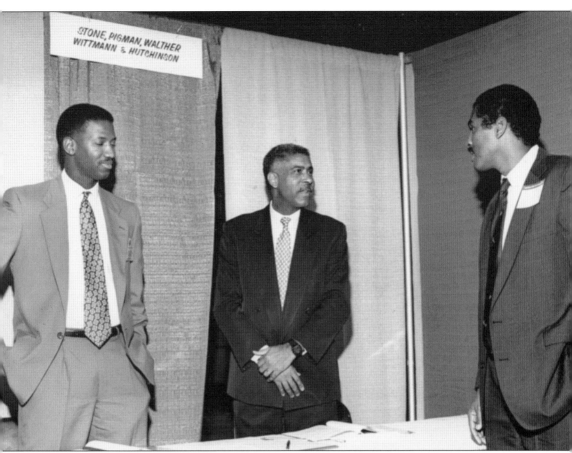

Marie Augustus, class of 1982, was named development assistant in 1985 and was later promoted to development assistant/placement director. A description of the office listed in the 1975–1976 law school bulletin states that the services operated on a full-time 12-month basis for the benefit of law students and alumni. The purpose of the office was to assist in locating available jobs—legal and paralegal, part-time and full-time, temporary and permanent, in and outside the state of Louisiana. Assistance was also provided in career planning, self-evaluating, job-hunting; preparing for and taking interviews; and communicating with employers. Other placement directors have been Lucius Thomas, class of 1984; Vanessa Caston-Porter, class of 1990; Regina Ramsey James, class of 1996 (at the time of her employment the title was changed to director of career services); and Michelle Jackson. Tavares Walker, class of 2008, is the current director of career services. As more African Americans were being hired at large and mid-size law firms, representatives from these firms participated in career fairs at Southern. Pictured from left to right are Marcus Brown, class of 1988; Wayne Lee, from Stone Pigman Law Firm in New Orleans; and Danatus N. King of Phelps Dunbar in New Orleans.

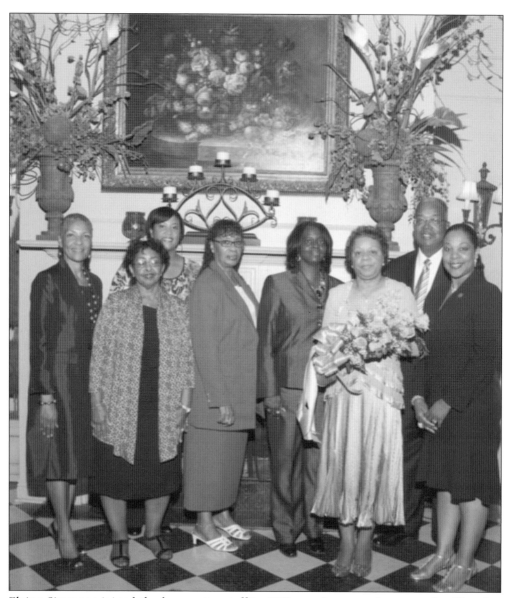

Elaine Simmons joined the law center staff in 1981, serving as assistant catalog librarian until 1985, when she was promoted to registrar and director of enrollment. Simmons coordinated the process that enabled the SULC Registrar's Office to operate independently of the Southern University Registrar's Office in 1986. Since that time, the office has expanded to include records and enrollment duties, recruitment, and admissions. The Rapides Parish native earned a bachelor of science degree from Grambling State University and a master of library science degree from Louisiana State University in Baton Rouge. Attending a retirement celebration of Associate Vice Chancellor for Records and Enrollment Simmons after 32 years of service to SULC are, from left to right, colleagues Andrea Love, Velma Wilkerson, Latonya Wright, Lois Daigre, Lena M. Station, Simmons, Chancellor Pitcher, and D'Andrea Joshua Lee. A scholarship established in her name is now supported by an annual gift from Simmons and her husband, Raymond Simmons, class of 1971.

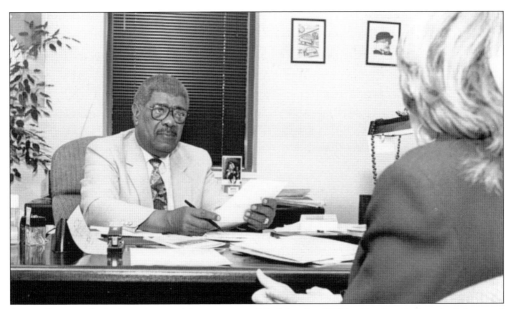

Several new administrative positions were added in the 1980s. Benjamin Lewis (pictured above) joined the law center as an assistant dean for student financial aid in 1982. Lewis earned promotions to director of financial aid and services in 1985 and director of financial aid in 1987. Jerome Harris succeeded Lewis as director of financial aid, and retired in June 2012. Billie Jo Langston was named coordinator of recruitment and public contacts in 1987, a position that eventually became two: director of admissions and recruitment and director of external affairs today.

Bertell Dixon, a 1970 SU graduate with a bachelor of science in accounting, became SULC's first budget officer in 1988. Dixon formerly worked in the SU Comptroller's Office from 1971 to 1988. At SULC, the New Roads, Louisiana, native and resident was promoted to director of financial affairs and, later, to associate vice chancellor for financial affairs. Terry Hall succeeded Dixon as associate vice chancellor.

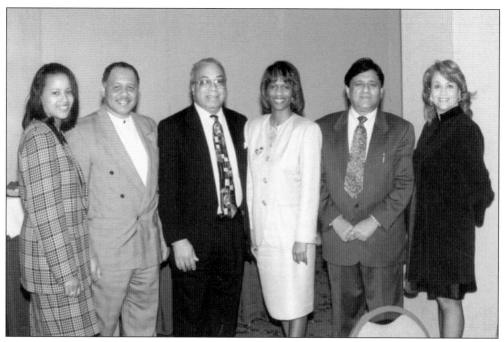

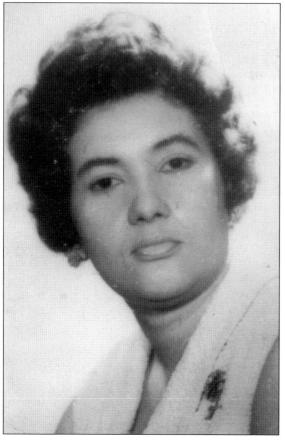

Berryl Gordon-Thompson, class of 1993, was named director of development and alumni affairs, and Audrey D. LeBlanc, class of 1958, was appointed director of academic support programs and executive assistant to the chancellor at SULC in 1993. Gordon-Thompson created the law center's first magazine, *Reflections*; developed the *Lenoir Legacy* newsletter; and produced the school's first recruitment video. The former executive assistant to the chancellor was associate vice chancellor for academic support and counseling at her retirement in 2016. Gordon-Thompson (above, at right) is pictured at a law center alumni event with, from left to right, Valerie Blunt, class of 1993; Arthur Thomas, class of 1976; SU System president Leon R. Tarver; Paula Hartley Clayton, class of 1990; and Chancellor B.K. Agnihotri. LeBlanc (at left) had previously served as executive assistant to SU president Jesse N. Stone. (Courtesy of Jelynne LeBlanc Burley.)

Three

THE HALLOWED HALLS
BUILDINGS AND GROUNDS

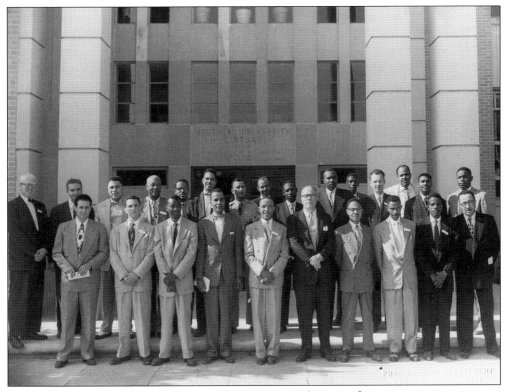

Reportedly, Louisiana was the first Southern state to admit an African American to its state bar. Jim Crow laws kept the number of black lawyers in Louisiana to a mere handful until Southern's law school was established. This group of lawyers attending Southern's Annual Law Institute includes Ernest "Dutch" Morial (first row, second from left), who in 1960 was LSU's first black law graduate—10 years after Southern's first law graduating class.

On September 1, 1947, the Southern University Law School was opened for classes initially held in a designated area on the second floor of the campus main library. The law school, housed in the university library, occupied two offices on the first floor of the library for its dean and its faculty, a seminar room on the second floor, and a portion of the attic where the law library was located. The first law librarian, C. Vernette Grimes, organized the law library collection with the benefit of a major donation from the Russell Sage Foundation of New York.

In 1951, the Southern University Law School was erected in the former library building. Opened for the 1952–1953 school year, the law school included administrative and faculty offices, an equipped practice courtroom, law review office, and class and seminar rooms. Johnnie Jones, the only member of the class of 1953, quipped years later that he was such an important law student that the State of Louisiana erected the school just for him.

Surrounded by the lovely architecture of the university library, the law school was just a stone's throw away from the spectacular view of the Mississippi River, as well as scenic Lake Kernan. Alumni recall that they looked forward to getting lunch and walking outside to sit on the river's bluff. The exercise, fresh air, and calming effect of the flowing water were just what they needed to return renewed for more hours of classes or studying. Their visits to the campus years later have had the same calming effect. (Both, courtesy of J. Naville Oubre/SU Publications.)

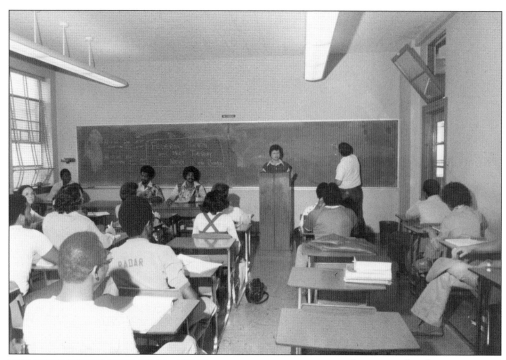

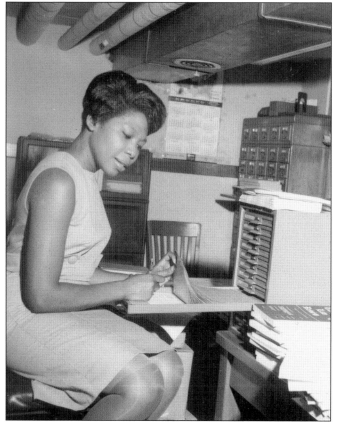

Concerns for the proper upkeep of library books eventually provided improved conditions for students to study. Dean Lenoir's desperate pleas to the university presidents for air-conditioning in the law library to preserve its holdings were answered in 1963. The air-conditioned law library boasted holdings that had more than tripled in size from its initial holdings to 38,000 volumes in 1969. Before 1963, law students managed a more comfortable study environment by disregarding the library's closing hours and securing entry at night. A designated study partner would hide in the restroom during building lock-up, only to come out after security check and let other students in after sundown when it was much cooler.

On February 18, 1978, Southern System president Jesse N. Stone presided over a ceremonial ground-breaking for a $1.5 million addition to the law school. Estella Lenoir, widow of Southern's first law dean; former law dean Vanue Lacour; and Southern president emeritus G. Leon Netterville Jr. were among those in attendance. New classrooms, faculty offices, a seminar room, and a student lounge would be added during several expansion phases.

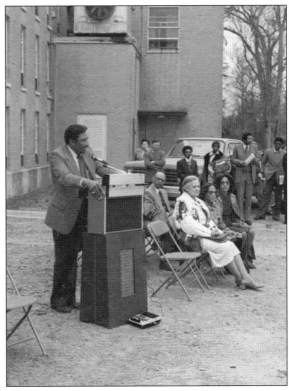

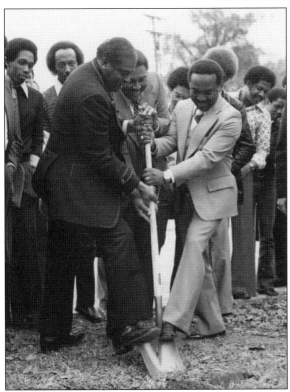

The first phase would take several years. The space between the law school and the university library would be used for the expansion, as well as space behind the law school and the library. This annex would constitute a new wing to provide more classrooms and office space and an atrium-style lounge. Richard Turnley, class of 1973, chief executive officer of the Southern Teachers and Parents Credit Union, is pictured (right) assisting President Stone (center) with turning the ground to mark the official beginning of the construction project. Turnley and Johnnie Jones, class of 1953, were elected to the Louisiana Legislature in February 1972.

The second phase of the law school expansion began in 1980. The work on the $4 million expansion and improvement project required the law faculty, staff, and students to be housed elsewhere on the Southern campus. Despite the inconvenience of having to relocate to other facilities, including several white wood-frame houses, known as "the cottages," administrators, staff, students, and alumni persevered in their duties as they eagerly awaited the opening of new expanded facilities.

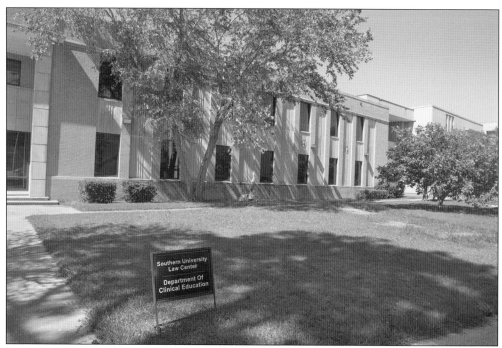

The project called for the complete renovation of the adjoining old university library building to have all law school operations under one roof. The entire building would have central heating and air conditioning, and an elevator would be installed, which would make the law school compliant with Americans with Disabilities Act (ADA) requirements. A study area, offices for student organizations, faculty, staff and student lounges, seminar rooms, and a renovated moot courtroom equipped with audio and video system for closed-circuit telecast into the classrooms were included, as well as space in the new West Wing for the Clinical Education Program.

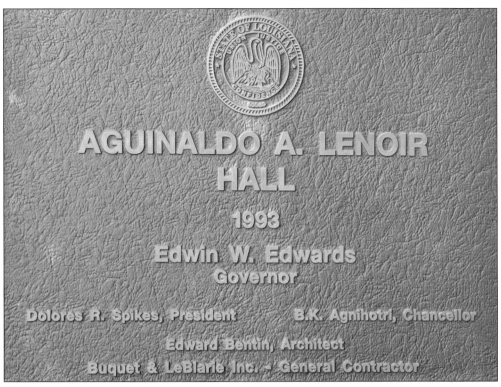

AGUINALDO A. LENOIR
HALL

1993

Edwin W. Edwards
Governor

Dolores R. Spikes, President B.K. Agnihotri, Chancellor

Edward Bentin, Architect

Buquet & LeBlarie Inc. – General Contractor

SU honored its first dean in naming the newly expanded law center building, Aguinaldo A. Lenoir Hall, in 1993. No doubt this new facility completed in January 1994 would have been a dream come true for Dean Lenoir, who had to continually make his case for the fundamental needs required to attract students and operate a first-rate institution. Lenoir believed in his faculty members and their ability and willingness to pursue their appointed purpose. Within the hallowed halls, they would seek to achieve the following set forth by a faculty committee appointed to study the school curriculum after the school's first seven terms: to ground students in the fundamentals; develop their analytical abilities and thought processes for clarity with expedition as a lawyer; foster in them devotion to ethical and moral standards; teach clarity of oral and written expression; and impart practical values, such as well-developed skills and techniques.

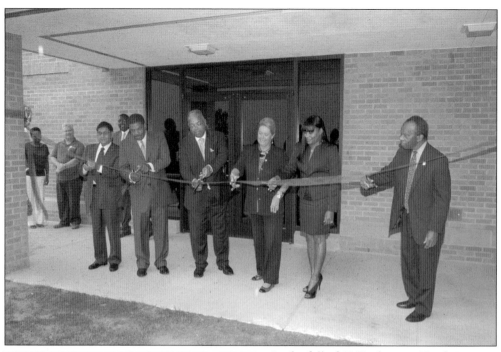

In the fall of 2009, the new North Wing opened with a ceremonial ribbon cutting on a building expansion that added 13,400 square feet to the 85,000-square-foot law building. Chancellor Freddie Pitcher Jr. said the long-awaited expansion came just in time to accommodate the largest student body in SULC history. Pictured from left to right are chancellor emeritus B.K. Agnihotri, SU Board chair Tony Clayton, Chancellor Pitcher, Louisiana Supreme Court chief justice Catherine "Kitty" Kimball, SU Board vice chair Lea Montgomery, and SU System vice president Tolor White.

The addition includes three new classrooms that provided students with a state-of-the-art learning environment, faculty offices, a lounge, restrooms, and additional elevator services at the law center. More than 2,000 square feet of additional library stacks and seminar space to accommodate up to 12 are available. Vice chair Montgomery and Chancellor Pitcher turned the ground at the base of a magnolia tree planted in the neutral ground between the old and new building additions.

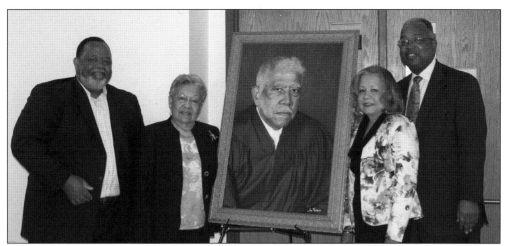

The first-floor classroom entryway of the North Wing provides wall space for the hanging of gallery-quality portraits of alumni members of the judiciary that now make up the SULC Judicial Wall of Fame. Pictured with a portrait of the late Louisiana Supreme Court justice Revius O. Ortique Jr., class of 1956, the first hung on this wall of honor are, from left to right, photographer James Thorn; Miriam Ortique, widow of Justice Ortique; Rhesa O. McDonald, his daughter; and Chancellor Pitcher.

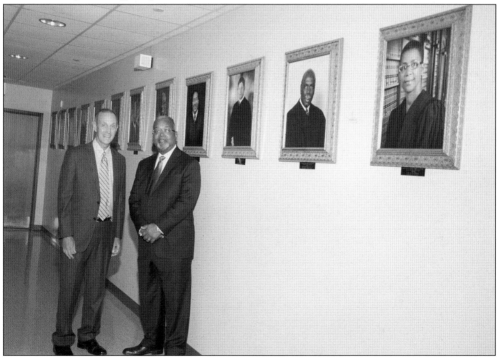

Chancellor Pitcher discusses with Louisiana Supreme Court justice John Weimer the number of SULC graduates in the judiciary, including a number of "firsts" in their prospective areas. Justice Weimer and Chancellor Pitcher are pictured after viewing the SULC Judicial Wall of Fame. The current group of 62 portraits represents annual installations provided by alumni judges who are recognized during a ceremony highlighting their career achievements.

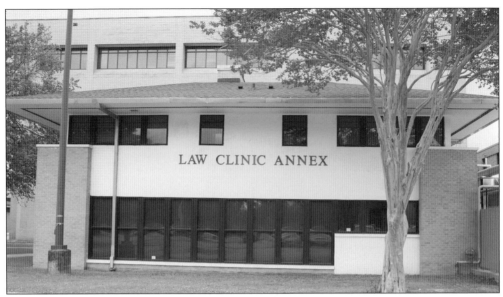

The opening of the law center's Clinic Annex in 2012 provides an additional 3,148 square feet of space for the Clinical Education Program. The Clinic Annex is designed to enhance the academic and administrative integration of the clinical programs. The dynamic space allows the operation of nine live-client clinics, using a law firm model, and facilitates student and faculty collaboration across the clinical experience. Reminiscent of the curriculum enhancement that the law school's Moot Court Program instituted in the 1949–1950 school year, the clinical experience produces greater practice-ready law graduates. SULC was the first law school in Louisiana to offer live-client limited-practice clinics. "These experiential learning opportunities help our students become more familiar with practice ready skills," Chancellor John Pierre says. "Thus, developing clinics is a strong component of clinical education, a tradition that SULC has embraced and continues to support." Pictured below from left to right, a student joins clinical professor Alvin Washington in the annex's conference room to prepare for a mediation session.

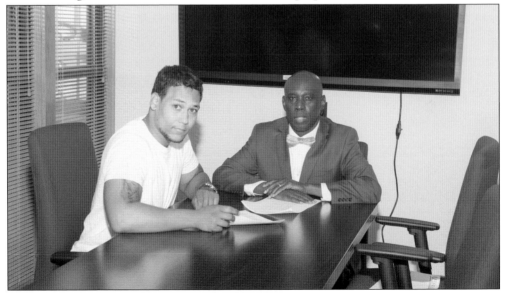

On September 29, 2016, the recently opened food court located in the atrium of A.A. Lenoir Hall became the King's Court, in honor of one of the law center's significant alumni supporters, former Judge C. Hunter King, class of 1988. "The official naming ceremony for the King's Court was a milestone for SULC, when one of its alumni contributes significantly to create opportunities to attract and retain those who embrace our mission and prepare to become the lawyer-leaders of the future," Chancellor John Pierre said. The food court, which opened in August 2015, is an example of the growth in capacity of the law center over the past few years, despite the decline in state dollars. The space was developed with the partial enclosure of the law center's outdoor courtyard to allow indoor space for dining.

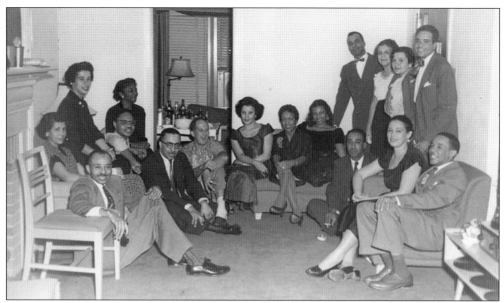

Dean Lenoir enjoyed the camaraderie of colleagues and family members. Lenoir also believed it was important to promote such get-togethers for faculty, students, and alumni and their family members. His home (above) and office were always open. Alumni from earlier years also recall gathering in the front of the law building and other favorite places on "the yard" to enjoy the educational experience. Whether inside or outside A.A. Lenoir Hall, law students—then and now—look for suitable spaces to study, share discussion with classmates and faculty members, relax between classes, and participate in social events. This 850-square-foot courtyard attracts students, faculty, alumni, and other supporters for all these reasons.

Four

ACCESS AND OPPORTUNITY
CLASSES AND STUDENT ACTIVITIES

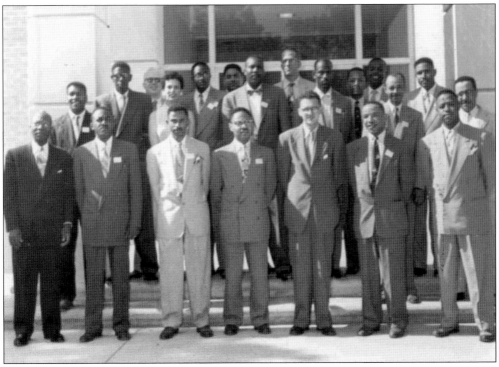

Because they had been seeing the worst in sociopolitical problems, many SU law students felt they had to fight for change and did so through the legal system alongside their law professors and peers. The law school's Annual Law Institute provided an excellent opportunity for members of the bar—as those pictured here—to exchange ideas and strategies. Institute attendees also recall the encouragement they received from each other.

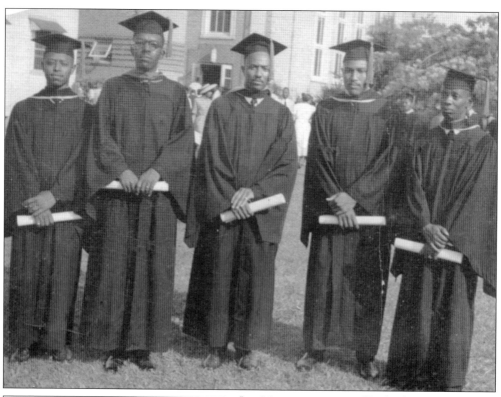

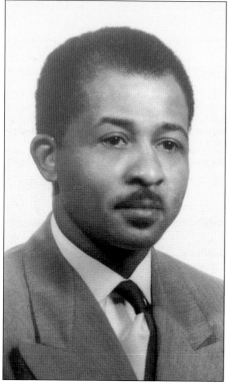

Louisiana was reportedly the first Southern state to admit an African American to its state bar; however, until the establishment of the Southern University Law School, Jim Crow laws enacted in the 1880s kept the number of African American lawyers to a mere handful. Southern's first law school class formed the nucleus of what would become Louisiana's modern African American bar. Pictured at their 1950 commencement are, from left to right, Alex L. Pitcher, Leroy White, Ellyson F. Dyson, Jesse N. Stone Jr., and Alvin B. Jones. At left (not pictured above) is St. Elmo Johnson. Noted civil rights attorney Pitcher was a former NAACP branch president. He left Baton Rouge in 1961 for San Francisco, California, where he continued his law practice and was elected president of the San Francisco NAACP branch. He died January 6, 2000. Jones and Johnson practiced law in New Orleans. Dyson, of Franklinton, Louisiana, was a longtime educator in his hometown. Stone became a Shreveport civil rights attorney and achieved many significant firsts in law, politics, and education. White practiced law in Baton Rouge for more than 30 years.

Unclassified students, who had obtained law degrees from common law states, acquired instruction in Louisiana civil law by attending classes at Southern University Law School. Among those certified by Southern during the school years between 1949 and 1954 were Earl Joseph Amedee, James E. Hines, and Jerome T. Powell, Howard graduates; Israel M. Augustine Jr. and Forrest F. Foppe, Lincoln graduates; and Oliver B. Spellman, Brooklyn Law School graduate. Appointed by Gov. John McKeithen to Orleans Criminal District Court in 1969, Augustine (above, at right with SU president Jesse N. Stone) was the first African American to serve as a state district judge in Louisiana. He was elected to the court in 1970. He presided over the 1971 Black Panthers trial, which brought him national attention. Powell (at right) practiced law in Shreveport, Louisiana, and was a founding statewide officer of the Louis A. Martinet Legal Society in 1957. (Above, photograph by John H. Williams, courtesy of *The Advocate*; right, courtesy of the Powell family.)

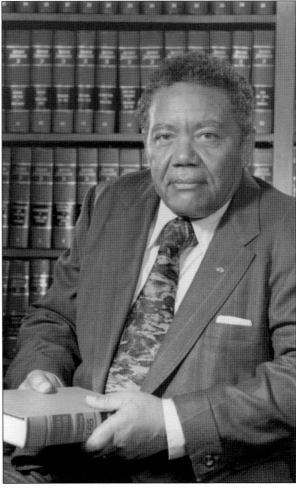

Leonard Avery of St. Tammany Parish, Louisiana, and Richard Millspaugh, born in Detroit, Michigan, and reared in Opelousas, Louisiana, were members of the class of 1951. An expert in collections judgments, Avery was an assistant district attorney in St. Tammany Parish and retired as an assistant US attorney in the Eastern District of Louisiana. Pictured above, Millspaugh, who entered private practice in Opelousas after law school, joined the NAACP and was the first black resident to register to vote in that city. He was city attorney for more than 30 years and was assistant district attorney for the 27th Judicial District Court of Louisiana for 20 years. He organized the St. Landry Community Services, Inc., in 1965 and served as its board chairman. He also was an adjunct law instructor at Southern.

Members of the class of 1952 Bruce Bell, Albion Ricard, Antoine M. "Mutt" Trudeau, and Freddie B. Warren Jr. were admitted to practice law in Louisiana the same year that Ralph Ellison became the first African American to receive the National Book Award for his novel *Invisible Man*. The author addressed what it means to be an African American in a world hostile to the rights of minorities. Bell opened a private practice in Baton Rouge. Before his death in February 1964, he practiced with his brother, Murphy Bell, a 1958 SU law graduate. Ricard, Trudeau, and Warren practiced in New Orleans. A World War II veteran, Trudeau (at right) was appointed cooperating attorney to the NAACP LDF by Thurgood Marshall in 1954, becoming co-counsel of civil rights cases until his death in 1978. Trudeau succeeded in ending school segregation in Jefferson Parish. The past president of the NAACP State Conference of Branches and of the Urban League of Greater New Orleans was appointed by President Eisenhower to the Commission on Governmental Contracts and was a New Orleans assistant city attorney. Trudeau is pictured below seated (at left) with James Garrison, and Lawrence Wheeler, class of 1957; and (standing, from left to right) attorneys John Blanchard and Henry P. Julien Jr. (Courtesy of Amistad Research Center/*Louisiana Weekly* collection.)

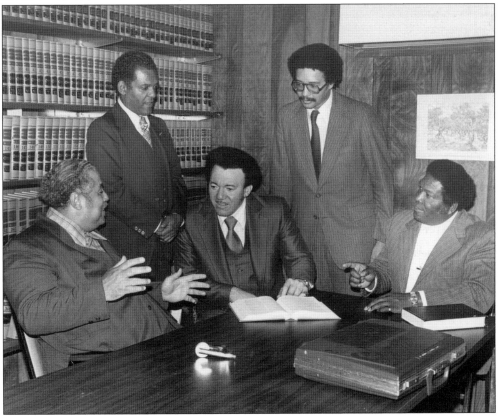

Native of Laurel Hills, Louisiana, and longtime Baton Rouge resident Johnnie A. Jones Sr., the only member of the class of 1953, is a strong believer that positive change can be made through the law. Fifteen days out of law school, he was legal counsel for the 1953 Baton Rouge bus boycott. He also shared in the successful representation of the 1960 Baton Rouge sit-in participants and served in the Louisiana House of Representatives in the 1970s and as the first African American assistant parish attorney for East Baton Rouge Parish. Jones, a veteran of World War II, believes that "Everyone is charged with a mission to make an improvement in civilization during the era in which they live." Jones is pictured (front row, right) with some of the participants in the 1960s sit-ins, who were attending the law center's 2006 public premiere of the documentary *Taking a Seat for Justice: The 1960 Baton Rouge Sit-Ins*.

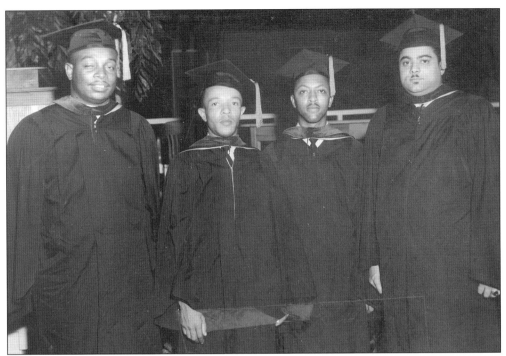

Class of 1954 members pictured with Dean Lenoir are, from left to right, Prudhomme Dejoie, Lenoir, Wilmon Richardson, and Chris Roggerson Jr. Dejoie practiced in New Orleans and, later, in Chicago, where he died in 1991. Richardson was a Baton Rouge attorney and businessman. Roggerson, a retired senior federal executive and lead counsel of the US Board of Veterans Appeal, said his proudest moment in public service was when he witnessed the Americans with Disabilities Act being signed into law in 1990. The Monroe, Louisiana, native and a more than 50-year LSBA member before he died in 2005 was a former supervising attorney, US Equal Employment Opportunity Commission; deputy director to the secretary, USHEW's Office of Civil Rights; and staff director for present-day US Supreme Court justice Clarence Thomas. Below, Roggerson, second left, enjoys the camaraderie of SU Law School administrators, faculty, and students.

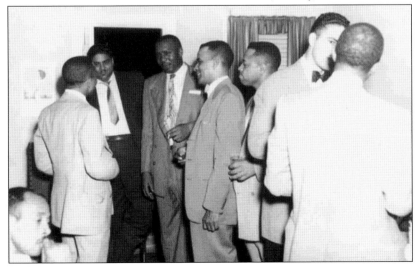

Leo F. McDaniel and Norbert Rayford were the class of 1955. McDaniel practiced law in Shreveport. After graduation, Rayford moved to Washington, DC, and then to Chicago, Illinois, to work in unemployment compensation. Rayford acknowledged at the time he was admitted to the Louisiana bar that "black attorneys were subjected to racial discrimination, prejudice, and mistreatment, just like other African Americans, even in court." "I give a lot of credit to attorney Johnnie Jones and the others for staying in the south and sticking it out." In 1973, Rayford returned to Baton Rouge for employment as an assistant law professor at Southern and, later, as an assistant city prosecutor. He was named one of the first commissioners in the 19th Judicial District Court, East Baton Rouge Parish, presiding over prison civil lawsuits at the Louisiana Department of Corrections at Angola. Rayford was an administrative law judge from 1990 to 1995 for the Louisiana State Department of Labor, Workers' Compensation. Rayford is pictured second row on the right with other 50-year members of the bar recognized at the LSBA midyear meeting in 2005, shortly before his death. (Photograph by Randy Bergeron, courtesy of *Louisiana Bar Journal*.)

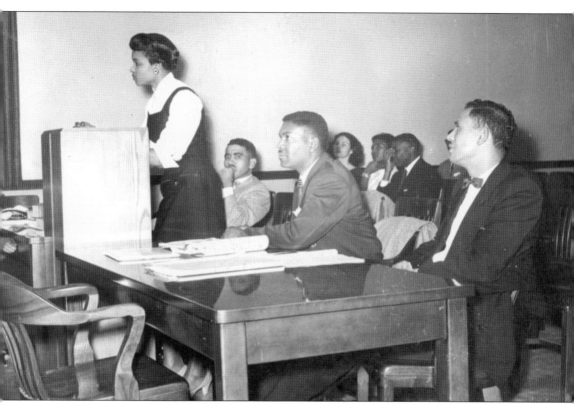

Mary Gloria Wilson Lawson is shown presenting oral arguments during an appellate presentation in the Moot Court Program required of all SU law students. Seated behind her to the left is fellow classmate Revius O. Ortique Jr. of New Orleans. Modeled after and conducted in accordance with the actual proceedings of the state court of Louisiana, the Moot Court Program afforded students practical experience under the direct supervision of a faculty member. As described in the law school bulletin for the 1949 to 1950 school year, the program included training in the use of the law library, the analysis and solving of legal problems, the drafting of briefs, and the presentation of oral arguments. Law students instituted actions in these courts and conducted them through the various stages to final judgment of decree. Students were "required to take entire charge of and to be responsible for his case . . . This work carried no credit hours toward a degree."

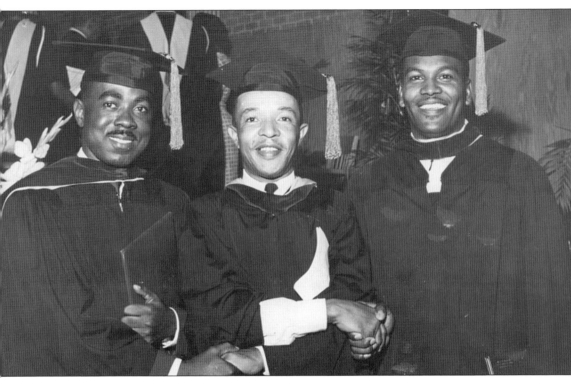

Pictured from left to right are Murphy Bell, Dean Lenoir, and Lawrence A. Wheeler during the 1957 SU commencement. Bell became a Baton Rouge attorney active in Louisiana's civil rights movement. As state counsel for the NAACP, attorney for the NAACP Baton Rouge branch, special counsel for the Louisiana Education Association (LEA), and cooperating attorney for the NAACP LDF, Bell handled sit-in demonstrations and school desegregation cases and defended civil-rights activists, such as Emmitt J. Douglas, H. Rap Brown, and James Farmer, in the 1960s and 1970s. Bell later became first executive director of Baton Rouge Public Defender's Office. He died in 2008. Wheeler, a native and lifelong resident of New Orleans, was a graduate of McDonough No. 25 High School, Dillard University, and Hastings Law School of California. He practiced criminal law in his own law office before his death in 2005.

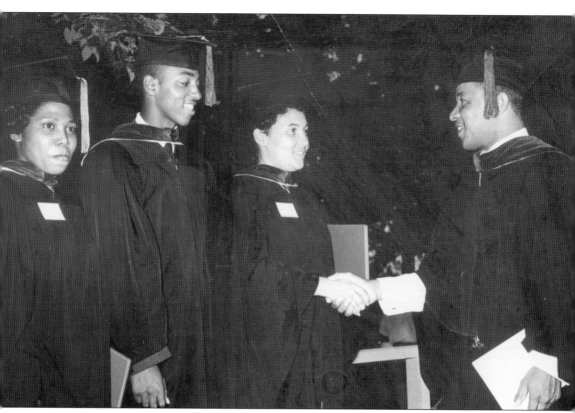

Dean Lenoir (right) congratulates members of the class of 1958, from left to right, Gwendolyn B. Crockett, Nathaniel Gales, and Audrey Daste LeBlanc. Crockett of Monroe, Louisiana, was an SU law instructor and was director of the Legal Aid Society of Baton Rouge. She moved to Maryland in the 1970s, where she was employed at the US Department of Labor and, later, at the US Consumer Product Safety Commission. Crockett also practiced law as president of Crockett & Johnson, PC, until she retired in September 2005. Gales of St. Joseph, Louisiana, and a US Marine veteran, served in the JAG Corps. LeBlanc was executive assistant to the chancellor and director of academic support programs at the law center from 1993 until her death in 1997. The New Orleans native formerly served as a research coordinator for the Louisiana State Constitutional Convention and was assistant to SU System president Jesse N. Stone Jr. (Courtesy of the Southern University Archives/John B. Cade Library/Simuel Austin Collection.)

Samuel Dickens and Isaac E. Henderson were members of the class of 1959. Dickens, pictured seated at right, enjoys one of his favorite law school training exercises, matching wits with his peers during moot court. The Tallulah, Louisiana, native entered the private practice of law in Baton Rouge and served as an investigator for the East Baton Rouge Parish District Attorney's Office. He died on November 15, 2000. Chancellor Freddie Pitcher Jr. (below, right) is pictured congratulating Golden Alumnus Isaac B. Henderson of Houston, Texas, during the 2009 SULC commencement. (Golden alumni are individuals who have served 50 or more years in the practice of law.) The New Orleanian's law career began in Baton Rouge at the Louisiana Committee on Parolee Rehabilitation. Henderson also practiced law in Lake Charles, Louisiana, before opening his law office in Houston, in March 1960, where he practices criminal and civil law in Louisiana and Texas.

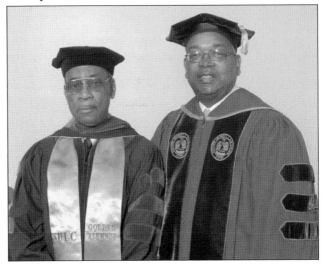

In 1960, law student John Will Johnson (right) was among seven SU students arrested for sitting in at the Baton Rouge Kress Department Store's white-only lunch counter. Johnson carries a pair of socks he purchased to avoid a vagrancy charge. He and the other students were charged with disturbing the peace. Expelled from Southern, Johnson later earned his juris doctorate from Howard University Law School and a master of laws from Georgetown University Law Center, before practicing law in New York. Pictured just behind Johnson is Donald Moss, another law student demonstrator. (Courtesy of *The Advocate*.)

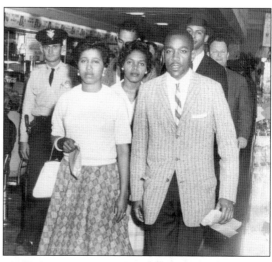

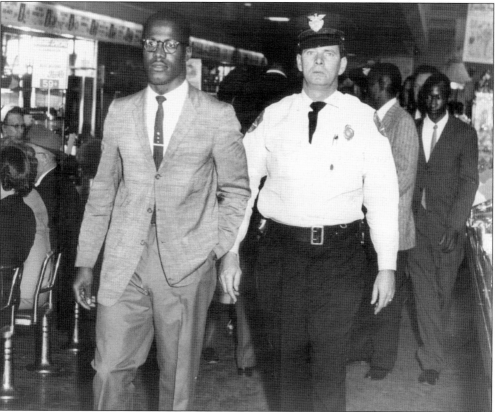

Law students John Garner of Baton Rouge and Kenneth Lavon Johnson of Columbia, Mississippi, were sit-in participants at Sitman's Drugstore in Baton Rouge on March 29. They and other Southern students who protested Jim Crow laws during the 1960 sit-ins were expelled from the university. Johnson, a 1962 Howard University law graduate, served as a City Circuit Court judge in Baltimore, Maryland (from 1982 to 2001). Garner, who died in 2012, was a US Army veteran and New Orleans police officer. (Courtesy of *The Advocate*.)

Dean Lenoir (above right) congratulates James E. Young Jr. of New Orleans, the only member of the law school graduating class of 1960. An LSBA member for more than 50 years, Young entered private practice in New Orleans and North Little Rock, Arkansas. With the expulsion of law students who participated in the 1960 sit-ins and 1961 demonstrations, there were no graduates of the class of 1961. The class of 1962 comprised Charles Finley and Paul Lynch (left). Lynch, a magna cum laude law graduate, entered the US Army as a first lieutenant in 1963. Lynch returned to Shreveport in 1969 and practiced law with Jesse N. Stone. In 1971, he became an assistant US attorney and handled several high-profile murder cases in the Virgin Islands. In 1979, Lynch was sworn in as the first African American elected district judge for Caddo Parish. (Courtesy of Milloy's Photo-Graphics Studio/Milloy Family Collection.)

Members of the class of 1963 included Mildred Byrd, Thomas Todd, Marion White, Nathan Wilson, and Bertel Winder Sr. Pictured above, Dean Lenoir (right) congratulates Todd, a magna cum laude graduate, during the 1963 commencement.

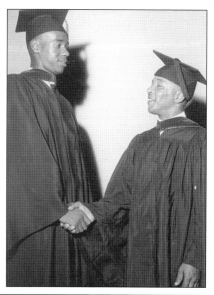

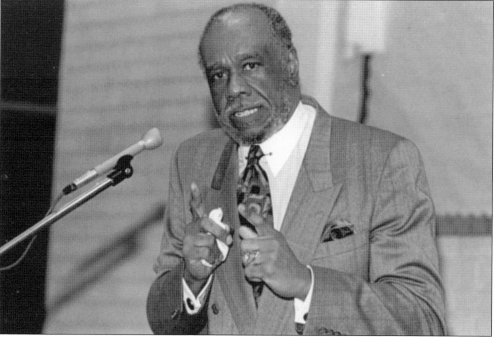

Thomas Todd (pictured), an activist attorney, civil rights spokesman, and law professor, lives in Chicago, Illinois. He became widely known as "TNT" for his oratorical skills, which he has used as a powerful spokesperson for civil rights and education. He formerly served as a lawyer in the US Army and on the staff of the US Attorney's Office in Chicago. In 1968, he developed *United States v. Gorman*, the first criminal case against a Chicago policeman for deprivation of an individual's civil rights. The case ended in a hung jury. Todd organized and established the country's first civil rights office in a local US Attorney's Office and was the first black full-time law professor at Northwestern University. He served as president of the Chicago chapter of the Southern Christian Leadership Conference in 1971 and president of Operation PUSH from 1983 to 1984.

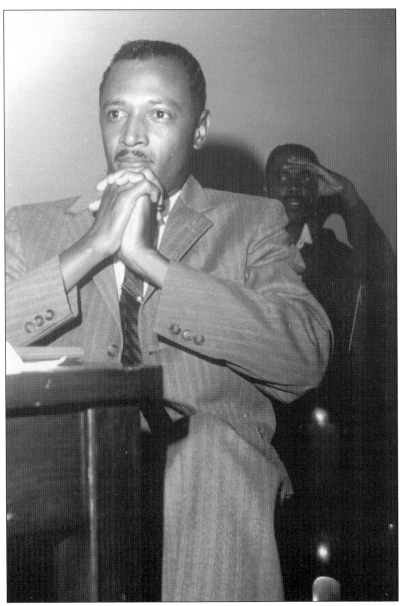

A resident of Opelousas, Louisiana, Marion White, class of 1963, practiced criminal and civil law, with a specialty in civil rights law. White has worked on behalf of the Congress on Racial Equality (CORE), NAACP, and local and state civil rights organizations on fair employment, voting rights, and civil and human rights litigation, including sit-in demonstrations. As a cooperating attorney with the NAACP LDF, he has litigated school desegregation lawsuits in 13 Louisiana school districts. In 2016, the St. Landry Parish School Board agreed to pay $800,000 in legal fees to White, as plaintiffs' attorney in a school desegregation case, which he initially filed against the school district in 1969. The US Army veteran and former state president of the Louisiana NAACP served as a member of the Louisiana State Advisory Committee to the US Commission on Civil Rights, which prompted federally mandated reforms at Angola State Penitentiary, and traveled to South Africa as the ABA's delegation to discuss the problems of apartheid.

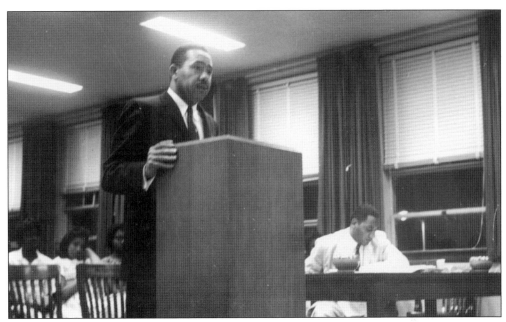

Above, Nathan E. Wilson, class of 1963, of Kansas presents during a moot court exercise. Wilson passed the Louisiana Bar Exam on his first attempt and joined the practice of law with his former professor Vanue B. Lacour, in one of the first law offices in the Scotlandville community, where Southern is located. Wilson was the first black assistant district attorney in East Baton Rouge Parish. He also taught at the law school.

Mildred Byrd, class of 1963, was an attorney for Capital Area Legal Services in Baton Rouge from 1968 to 1971. Byrd had a 37-year career with the Equal Employment Opportunity Commission offices in Washington, DC; Atlanta, Georgia; and Birmingham, Alabama, before retiring in 2008. The Bossier Parish native and her father, Clarence Byrd, demonstrated with freedom riders at the Greyhound Bus Station in Shreveport. Her father was also the plaintiff in the 1952 voter registration case, *Byrd v. Brice*. This civil rights activism inspired her (pictured) to enroll in law school.

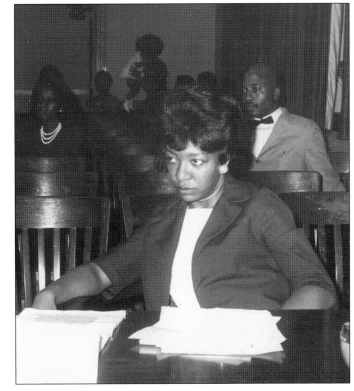

Bertel Tyrone Winder Sr., class of 1963, (seated at right) enjoyed the mock trial exercises because they provided the opportunity for him to match wits with fellow classmates. Winder and his family were residents of the Southern Heights subdivision in Scotlandville, just minutes from the Southern University campus. An avid reader, he was a teacher in East Feliciana Parish, pharmacist, and radio announcer for WXOK. After law studies, he went into private practice in his firm of Jones and Winders. Winder joined fellow law graduate Murphy Bell as associate director of Community Advancement, Inc. The World War II veteran died on July 29, 1969, at the age of 47.

The class of 1965 consisted of Walter L. Bailey Jr. of Memphis, Tennessee; Louis Guidry of Lake Charles, Louisiana; and Curtis A. Calloway of Alabama. Admitted to the Tennessee bar in 1966, Bailey (below, standing) has been involved in personal injury and civil rights cases, including the desegregation of Shelby County public schools, the legal defense of Martin Luther King Jr. during the 1968 sanitation workers' strike in Memphis, and successful lead counsel in the 1985 US Supreme Court case, *Tennessee v. Garner*. A Shelby County commissioner for more than 40 years, he is the longest serving elected governmental official in Tennessee. Guidry (above, sitting at center), the first African American city prosecutor in Lake Charles, has practiced in Acadia Parish as a voting rights advocate and in Lake Charles in civil and criminal litigation. After 19 years in private practice, Calloway (above, sitting at right) was elected Baton Rouge City Court judge in 1988 and to the 19th Judicial District Court bench in 1992, from which he retired in 2008. Judge Calloway has served ad hoc on the Second Circuit Court and the First Circuit Court of Appeal. There was no 1964 graduating class because of the temporary closure of the university in the aftermath of the 1961 demonstrations.

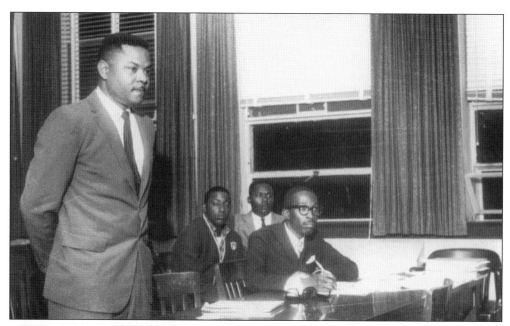

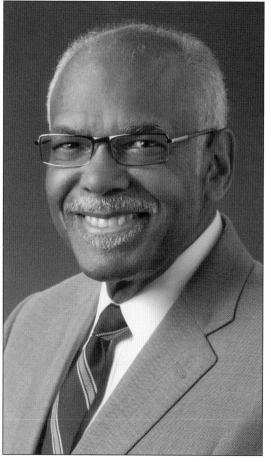

Members of the class of 1966 are Edward Larvadain Jr. of Alexandria, Louisiana; Arthur Thompson of Shreveport, Louisiana; Clyde Carzet Tidwell of Monroe, Louisiana; George West Jr. of Mississippi, and Charles White (pictured on page 78) of Vidalia, Louisiana. After passing the bar on the first try, Tidwell began a private practice of family and criminal law in Baton Rouge, dividing his time between practicing law, serving as Southern's law librarian, and for more than 40 years teaching law. His favorite course was legal research. SULC alumni have expressed fond memories of Professor Tidwell and his book truck filled with reference materials. An SULC endowed professorship was established in his name shortly after his death in 2007. Participating in the moot court session pictured above are Clyde C. Tidwell (sitting) and Louis Guidry (standing), class of 1965. Thompson (at left) is a longtime clerk of council for the City of Shreveport. (Left, courtesy of Arthur Thompson.)

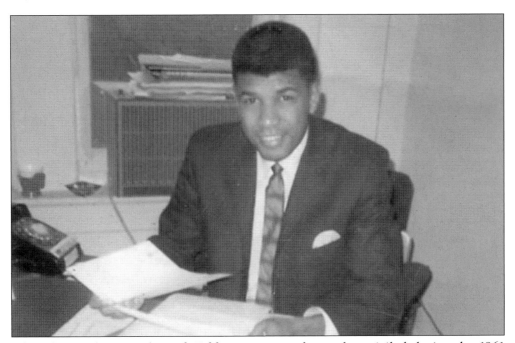

Edward Larvadain Jr., class of 1966, was among the students jailed during the 1961 student demonstrations in Baton Rouge. The ensuing 1964 US Supreme Court case, *Cox v. State of Louisiana*, was filed on behalf of B. Elton Cox and others who were charged with unlawful assembly and other crimes during these demonstrations. The Court decided that the state's action was in violation of the rights of free speech and free assembly. Larvadain was jailed for 30 days and felt that he was willing to serve even more jail time in protest against Jim Crow laws. The Assumption Parish native practiced law for one year in New Orleans in the Law Office of Ernest Morial. In 1967, he relocated to Alexandria, where he was employed as a staff attorney with the Central Louisiana Legal Services Society. Upon the death of former SU law dean Louis Berry, Larvadain took over as the attorney in the case of *Valley v. Rapides Parish School Board*, which desegregated schools in Rapides Parish. He established his Alexandria, Louisiana, law office in 1970, taking on other civil rights cases. Lavardain was among those inducted into the 2014 SULC Hall of Fame. Pictured below from left to right are Chancellor Pitcher; Mayor Jacques Roy, class of 1997; Lavardain; Judge Ramona Emanuel, class of 1986; Rickey Miniex, class of 1986; Judge Jeff Cox, class of 1992; Judge Wilson Fields, class of 1995; and Clyde Simien, class of 1986. (Above, courtesy of Edward Larvadain Jr.)

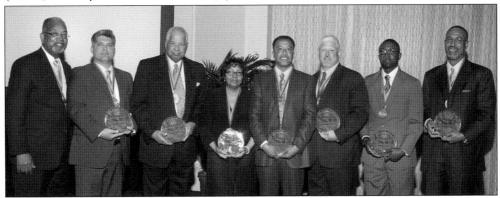

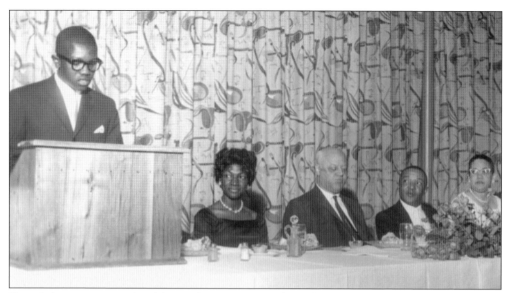

New Orleans attorney A.P. Tureaud was an invited speaker at the Student Bar Association (SBA) 1966 law banquet. The annual banquet continues today held in conjunction with the annual law week celebration, initiated in 1957. Pictured above are, from left to right, SBA president Charles White, Mattie White, Tureaud, Dean A.A. Lenoir, and Estella Lenoir. Pres. Felton G. Clark (below) also addressed the banquet. Times had been hard in the preceding years of Clark's tenure. Student expulsions and university closure because of the civil rights demonstrations left many supporters with mixed feelings about the president's decisions. In the 1966 school yearbook, he wrote, "Southern always has possessed the mind and the outlook of the students—ever willing and anxious to learn and practice how to become better." The US Supreme Court rendered a precedent-setting ruling in *Cox v. State of Louisiana*, in favor of the student demonstrators.

Robert C. Williams, the only member of the class of 1967, has been a legal advocate for civil rights throughout his legal career. Shortly after being admitted to practice in 1967, Williams served two tours in Vietnam as a lieutenant in the US Marine Corps, honorably discharged in 1971. He was general counsel for the NAACP Baton Rouge Branch and a longtime member of the NAACP LDF and the Louis A. Martinet Legal Society. He was legal counsel for Louisiana civil rights luminaries H. "Rap" Brown, former Louisiana NAACP president Emmett Douglas, and SU law graduate Robert Eames. His greatest civil rights litigation was as lead counsel in *Davis v. East Baton Rouge Parish School Board*, one of the longest-running school desegregation lawsuits in the country. Pictured during the 2017 SULC Lawyers Guild's Pillar Awards inaugural ceremony are, from left to right, (sitting) award recipient Johnnie A. Jones, class of 1953; Etta K. Hearn, class of 1969; recipient Robert C. Williams; and Alfreda Tillman Bester, class of 1999; (standing) former SU law instructor Gayle Horne Ray; Judge Pamela Taylor-Johnson, class of 1979; and recipient Ernest L. Johnson, class of 1976.

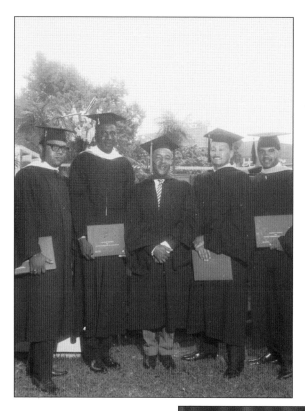

The class of 1968 is pictured with Dean A.A. Lenoir, from left to right, Theodore Carter of Alexandria, Virginia; Alfred E. Mitchell of Plaquemine, Louisiana; Lenoir; James J. King of Silver Spring, Maryland; and Robert J. Eames of Baton Rouge. Returning as keynote speaker at the 1969 Law Week Banquet, Mitchell commended the black lawyers of the South on their "wonderful" work, hoping that more African Americans would be inspired by them to enter the field of law.

As a result of the actions led by Walter C. Dumas, class of 1969, the Louisiana State Board of Education voted to change SULC's bachelor of laws to juris doctorate in 1969. The first to earn a juris doctorate from SULC were Dumas and classmates Arthur L. Harris Sr., New Orleans; Victor J. Hawkins, Gaithersburg, Maryland; Etta K. Hearn and Wilfret R. McKee, Baton Rouge; Joseph Hickman, Dallas, Texas; and Hilry Huckaby II, Shreveport, Louisiana. (Courtesy of Walter C. Dumas.)

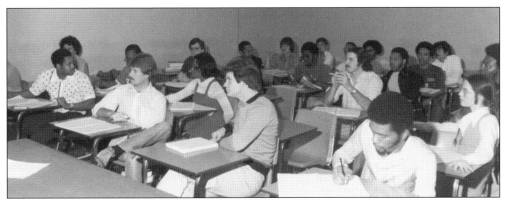

Dean Lenoir resigned in 1970. The decade of the 1970s represented significant historical developments for SU Law School. It was 16 years after the 1954 unanimous US Supreme Court's opinion in *Brown v. Board of Education* declaring that separate schools are "inherently unequal." Southern's first white law students were graduated, including Robert L. Comeaux, class of 1972, of Milton, Louisiana, and Eugene Cicardo Sr., class of 1973, of Alexandria, Louisiana. *United States v. Louisiana* was filed in 1974 by the Justice Department to force Louisiana's compliance with federal desegregation regulations. Law graduate Charles D. Jones, class of 1975, of Monroe, Louisiana, represented SULC in this case. Thomas Todd and Curtis Calloway were legal counsel for Grambling State University. Louisiana constitutional revisions in 1974 divided the direct governance of state universities into three boards, including the SU System Board of Supervisors. Law alumni were among the first members of the SU Board and continue to be appointees today. Cross-registration between the law schools of SU and LSU was initiated. Pictured below during the 1975 commencement are graduates, including Arthur Stallworth, second from right. (Below, courtesy of Arthur Stallworth.)

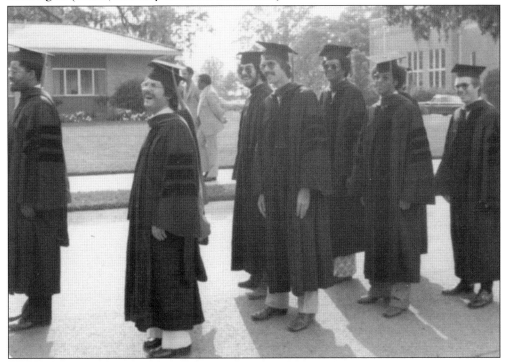

Longtime activist in legal and political circles Eugene Paul "Gene" Cicardo Sr., class of 1973, was a former Alexandria, Louisiana, city attorney, appointed in 1973. He was founder of the Eugene Cicardo Law Firm and served as president of Central Louisiana Legal Services and the Alexandria Bar Association. He was a member of the American Trial Lawyers, the Louisiana Trial Lawyers Association, the National Bar Association, and the ABA. According to Eugene Cicardo Jr., class of 1982, his family's history with Southern's law school began in 1969. The senior Cicardo worked as an independent insurance adjuster on the Gulf Coast during the aftermath of Hurricane Camille, where he developed an interest in going to law school. After earning an undergraduate degree in 1970, he enrolled in law studies at Southern with the help of many, including his good friend and mentor, former Dean Louis Berry. Cicardo's success in law studies and passing the bar on the first attempt was not without hard work, sacrifices of his family, and the dedication of the faculty and staff at Southern University. (Courtesy of Eugene Cicardo Jr.)

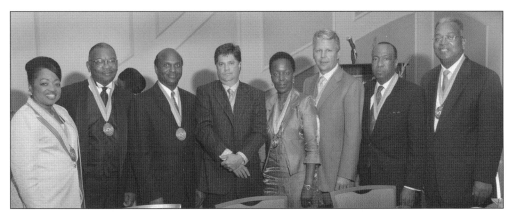

Willie James Singleton, class of 1973, immediately established a solo practice in Shreveport, Louisiana, after law studies and was elected to the Caddo Parish Police Trial Jury in 1976. Singleton served in the Louisiana State Legislature from 1983 to 1996 and is a former assistant state attorney general. His current practice areas include medical malpractice, wills, successions/probates, patents, brain spinal cord injuries, wrongful death claims, and product liability cases. Singleton is pictured with the 2007 inductees into the SULC Hall of Fame, from left to right, Annette Eddie-Callagain, class of 1981; Brace B. Godfrey Jr., class of 1985; Ernest Johnson, class of 1976, Chris J. Roy Jr., class of 1987; Judge Ethel Simms Julien, class of 1982; Louisiana State Representative T. Taylor Townsend, class of 1989; Singleton; and Chancellor Freddie Pitcher Jr.

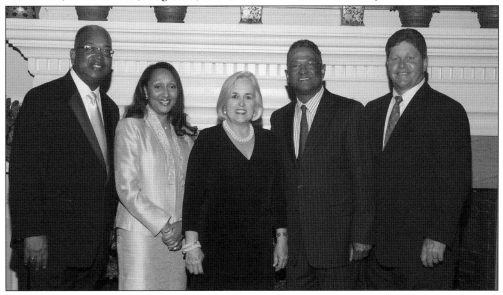

Judge Wayne F. Salvant, class of 1974, began his legal career as an investigating attorney with the US Securities & Exchange Commission (SEC) in Fort Worth, Texas. After three years with the SEC, he developed a successful private practice in Tarrant County, Texas. The US Marine veteran was appointed to the bench in Tarrant County's Criminal District Court No. 2 in 1995, was elected to that seat in 1996, and currently serving with re-elections since 2000. Pictured with Judge Salvant are, from left to right, Chancellor Pitcher and other 2011 Hall of Fame inductees US Attorney Stephanie A. Finley, class of 1991; Judge Toni M. Higginbotham, class of 1985; Salvant; and Judge J. Robin Free, class of 1989.

In his message in the 14th Annual Law Week Banquet program, SBA president Robert Skipper (left), class of 1977, wrote, "It is our aim, by focusing on challenges facing today's attorney, to reflect on the invaluable contributions by many in the past, and create a forum for intellectual exchange to assure this institution's continued existence. We . . . seek your active participation in the struggle." Other 1976–1977 SBA officers were Henry Jones, class of 1977, vice president; Edwin Burks, class of 1978, secretary; George Guillory, class of 1978, treasurer; Leon L. Emanuel III, class of 1977, parliamentarian; and Danny Dockery, class of 1977, editor of *Public Defender*. Wanda G. Henton (below), class of 1977, was law week committee chair. Other law week guest speakers were Lennox Hinds, national director of National Conference of Black Lawyers, and Louisiana Speaker of the House E.L. "Bubba" Henry. (Photographs by Art Lyons.)

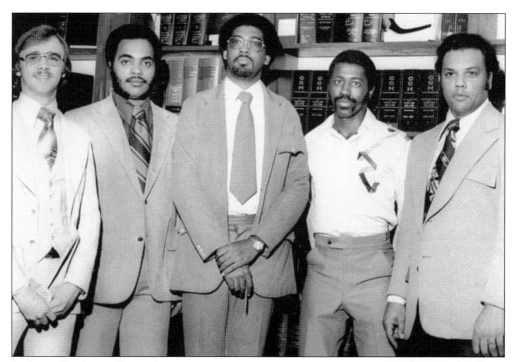

SU law school enrollment became consistently larger, averaging 31 graduates annually during the 1970s. The class of 1978 had 44 members, and the class of 1979 had 53. Pictured above, from left to right, are Joseph "Joey" Cannatella, class of 1978, of Shreveport; Albert Hicks, class of 1978, of New Orleans; SBA president Willie L. Rose, class of 1978, of Jackson, Mississippi; Robert Johnson, class of 1979, of Leesville, Louisiana; and SBA vice president Arthur Morrell, class of 1978, of New Orleans. Rose was an administrative law judge for Social Security, in the Office of Disability Adjudication and Review in Jackson. He was formerly an attorney with the Mississippi Center for Legal Services. Morrell is criminal clerk of court for Orleans Parish elected in 2006. He served in the Louisiana House of Representatives from 1984 to 2006. "I attended courses at other law schools during the summer and there you were given a number; at Southern Law School everyone used their names," Morrell said. Charles A. Shropshire (at right), class of 1979, became the first African American elected to the office of district attorney in Louisiana, serving in East and West Feliciana parishes from 1996 to 2002.

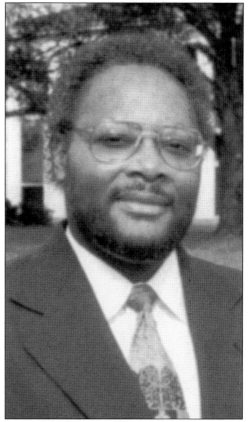

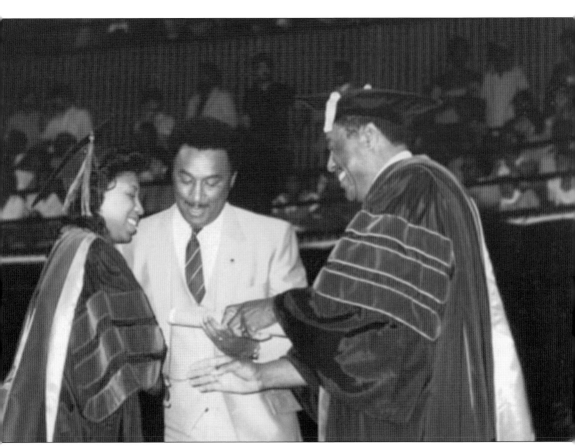

For most of the 1980s, Louisiana was under a consent decree negotiated by the US Justice Department with the state to create a better racial mix at historically segregated state colleges. From 1981 to 1987, more than $200 million in state funding went to Southern University and Grambling State University, with special enhancements dedicated to the law center. In an interview with a national newspaper, Pres. Jesse Stone said he believed that Southern's future depended on making "survival and enhancement of Southern a lively part of the political life" of black and white residents in Louisiana "who understand the importance to the state of educating all its students . . . With the consent decree we had some respite for permanence." Pictured during the 1983 commencement are, from left to right, law graduate Yolanda R. Johnson; her father, Dr. Joseph B. Johnson, president of Grambling (1977 to 1991); and President Stone.

Eugene Cicardo Jr., class of 1982, is just one in a number of family members who are SULC alumni called "legacy graduates." The legacy began with his father, Eugene Cicardo Sr., class of 1973, and continues with his sister Toni C. Gouaux, class of 1981; his brother Ross, class of 1984; Toni's husband, Gene Gouaux Jr., class of 1979; and his wife's niece, Allie Paige Nowlin, class of 2012. Cicardo is assistant secretary and general counsel for the Office of Legal Affairs of the Louisiana Department of Public Safety and Corrections. He has been a guest lecturer and continuing legal education presenter throughout the state and is also a member of the Rapides Parish Inns of Court. New lawyers Toni Gouaux (left), class of 1981, and Cicardo Jr. (right) are given the customary introduction to the local bar association by a current member, in this case Southern law dean Louis Berry, their father's mentor and friend. (Courtesy of Eugene Cicardo Jr.)

Other legacy graduates of note are East Baton Rouge Parish District Attorney Hillar Moore III, class of 1989; his sister, Judge Judy Moore Vendetto, class of 1996; and his daughter, Hayden A. Moore, class of 2013. First elected in 2008, Moore is in a second term as DA for the 19th Judicial District and is president of the Louisiana District Attorney's Association. With more than 40 years in the criminal justice field, his career recognitions include FBI Director's Award for Excellence, Louisiana State Police Colonel's Award for Excellence, and the 2010 induction into the SULC Hall of Fame.

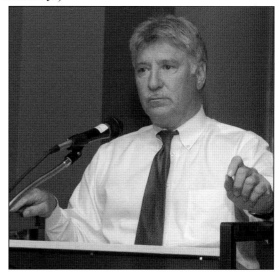

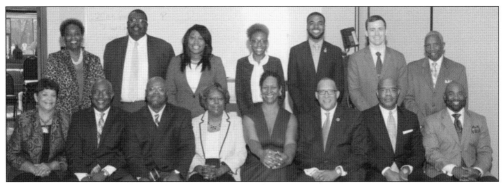

The class of 1985 is noted for many accomplishments, including that of one of its study group, called "The Corporation," for long-standing support of student scholarships. Since 1995, the group has presented more than $40,000 to 60 law students in honor of two of its deceased members, Tyrone Kee and Brace B. Godfrey Jr. Pictured during the 30th anniversary recognition of the group and its supporters are, from left to right, (seated) Cynthia Godfrey, widow of class member Brace B. Godfrey; Gregory Atwater; Ronald Ringgold; Gail Ringgold; Darlene White; Judge Brian Jackson; Dannye Malone, class of 1985; and Brace "Trey" Godfrey III; (standing) Adj. Prof. Monique Edwards; Interim Chancellor John Pierre; scholarship recipients Robin Winn, Sunseray Joseph, Jamar Myers-Montgomery, Patrick Harrington; and Vice Chancellor Russell Jones. Scholarship recipient Lamar Gardner is not pictured. Corporation members not pictured are Mike Corbin, Kevin Cunningham, and Robert Jenkins.

In 1986, the 23rd Annual Law Week Banquet carried the theme "Surviving the Trend: A Quest for Expansion and Stability in Legal Education." SU President Jesse N. Stone, who would soon be leaving his post as president for a professorship at the law school, addressed the audience of law students, faculty, staff, alumni, and other supporters, as alumnus Robert Williams (seated at left) looks on. Additional funding to the law center thanks to the consent decree had been put to good use, with cautious optimism of what was in store down the road. According to federal statistics, white enrollment at the law school had increased by only 2.3 percent over the pre-decree percentage. The *New York Times* reported that Stone was unperturbed about the scarcity of white students at Southern. "What I sought to accomplish with the consent decree," he said, "was enhancement of Southern University. If only blacks should choose to come, we need that enhancement." Other law week keynote speakers in the 1980s included Georgia State representative Julian Bond, Mississippi Supreme Court justice Reuben Anderson, and US congressman Mike Espy.

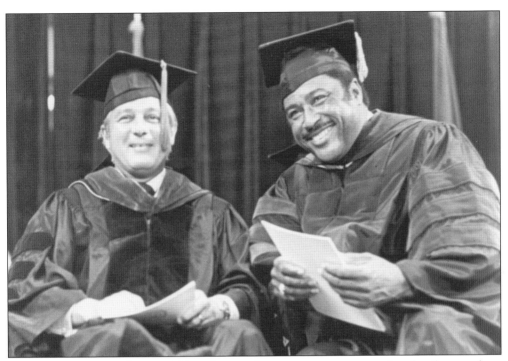

Louisiana governor Edwin W. Edwards was the commencement speaker for the members of the class of 1986, the first to graduate as a law center class. The exercises, held separately from the Baton Rouge campus commencement, were conducted in the Martin L. Harvey Auditorium on the bluff overlooking the Mississippi River. The auditorium was filled to capacity as the top student James Best, of New Roads, Louisiana, led the processional of the 108-member class. Best would later be elected judge in the 18th Judicial District, serving the three Louisiana parishes of Iberville, Pointe Coupee, and West Baton Rouge. Pictured above are Governor Edwards (left) and President Stone. Featured speakers for subsequent law center commencements have included Shreveport, Louisiana, native and noted defense attorney Johnnie Cochran, Congresswoman Sheila Jackson Lee, Congresswoman Stephanie Tubbs Jones, and New Orleans mayor Marc Morial. Pictured below, from left to right, are President Jesse Stone, Cochran, and Chancellor B.K. Agnihotri.

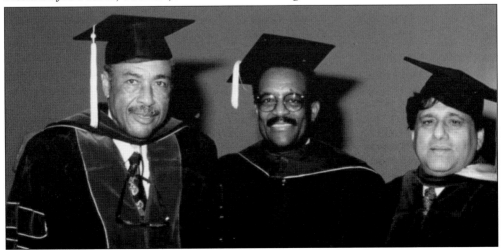

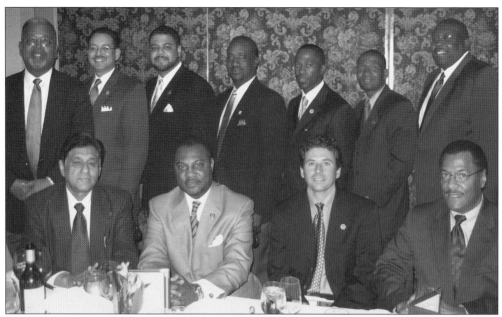

Plans for a merger with the LSU Law Center by the 1990–1991 school year did not materialize. With the Higher Education Desegregation settlement brokered with the US Justice Department in 1994 by Gov. Edwin Edwards, the 1990s represented the respite for permanency that President Stone had hoped for with the consent decree. SULC administrators are pictured above with alumni legislators. Pictured above from left to right are (seated) chancellor emeritus B.K. Agnihotri; Sen. C.D. Jones; Rep. Damon Baldone; and Vice Chancellor Arthur Stallworth; (standing) Chancellor Freddie Pitcher Jr.; Sen. Rick Gallot; Sen. Donald R. Cravins; Rep. Willie Hunter; Rep. Michael Jackson; Sen. Cleo Fields; and Vice Chancellor John K. Pierre. Below, standing is Baton Rouge mayor-president Melvin "Kip" Holden, former state senator (2002–2004) and representative (1988–2002), during his swearing-in ceremony on January 3, 2005, as Baton Rouge's first African American mayor-president. Holden served from 2005 to 2016, after being re-elected twice.

In 1995, former Mississippi judge Thomas E. Brennan's (composite index) ranking of the top 10 law schools in the country placed SULC at No. 10. What netted such a high ranking for the law center were its large library and a low student-faculty ratio. Chancellor B.K. Agnihotri believed that Brennan did a good job putting factors together that should be considered in rankings.

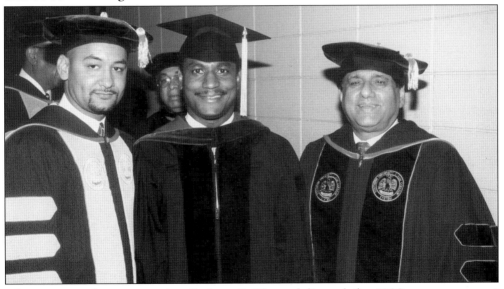

US secretary of transportation Rodney E. Slater delivered the 1998 commencement address. Honored to be at SULC during its 50th anniversary and to celebrate a campus that is one of the most integrated in America, Slater announced, "The House and Senate overwhelmingly voted to keep our Disadvantaged Business Enterprise program." This program has given minority- and women-owned businesses the opportunity to provide quality construction services across the country, he said. Pictured from left to right are SU Board of Supervisors member David Bell, Slater, and Chancellor Agnihotri.

In the 2000s, a revised SULC mission statement read, "The mission and tradition of the law center are to provide access and opportunity to a diverse group of students from underrepresented racial, ethnic, and socio-economic groups to obtain a high quality legal education with special emphasis on the Louisiana civil law." SULC has been cited as among the top in the nation for faculty and for student ethnic and gender diversity, as well as most chosen by older students. Student diversity is featured in the 2016 Chancellor Award winners, (pictured above, from left to right) Dax Ramsey, Krysie Wilson, Amy Anazia, Jacqueline Afdeyemi, Elizabeth Bloch, Cassandre Michel, Ada Goodly, Patrick Harrington, unidentified, Farah Gheith, JaQuay Jackson, Alvarex Hertzock III, Kristin Bluain, Xavier Nelson, and Jamar Myers-Montgomery; and in 2009 student ambassadors (below, from left to right) Jared Newchurch, Andrea Lowe, Robert Pearson, Lam Tram, Raushanah Hunter, Stephanie Robin, Erika Green, and William Jorden.

Associate Justice, later to become Chief Justice, Bernette Joshua Johnson (right) of the Louisiana State Supreme Court, commencement speaker for the 103 members of the 2003 graduating class, acknowledged the important role of the law center as one of only four remaining historically black law schools. Justice Johnson reflected on the changes in the legal profession from the time she entered in 1969. "There are more women and minorities in the law schools and in the law firms," she said. "It has taken effort and lawsuits to create diversity in the profession and on the bench." The class of 2003 Law Review graduates are pictured below from left to right: Kenneth "Chip" Waguespack, Ralph "Trey" Parnell, Niles B. Haymer, and Jason J. Ben.

Faith E. Jenkins, class of 2003, of Shreveport, Louisiana, says graduating at the top of her law class was her greatest achievement. Jenkins, the first African American crowned Miss Louisiana and first runner-up to the 2001 Miss America, remains the only contestant in the pageant's history to be awarded the swimsuit, talent, and Quality of Life awards. Jenkins chose SULC for law studies from among a number of other schools that accepted her for admission. "Many great lawyers have attended this law center. I wanted to follow in their footsteps," she said. After all she has accomplished during her law school career, including completing a 2002 summer clerkship with Sidley, Austin, Brown, and Woods in New York, the recipient of the Cicardo Legal Award for Academic Excellence began a career in general litigation with that firm, making a six-figure salary. She has appeared regularly on CNN, MSNBC, and Fox News as a legal analyst, and she now hosts her own syndicated legal reality show, *Judge Faith*. Other alumni television and radio legal analysts and program hosts include Jacqueline Scott of Shreveport; Alfreda Tillman Bester, Taryn Branson, Ernest L. Johnson, Arthur Thomas, of Baton Rouge; and Yodit Tewolde of Dallas, Texas.

SULC began offering its first dual degree, the juris doctorate and master of public administration, in the 2003–2004 academic year. Among the first to earn the dual degree were 2004 graduate Drusilla I. Henley of Baton Rouge and 2006 graduates, pictured from left to right, Tremayne Temetrius Dowell, Prichard, Alabama; Troynel Denise Boudy, Baton Rouge; April Charmain Bailey, Atlanta, Georgia; and Sean A. Varnado, Baton Rouge.

Louisiana governor Murphy "Mike" Foster, class of 2006, (above, second from right) enrolled as the first student in the SULC part-time day program. The governor applauded the law center for giving him a chance to study law, even though he was in his 70s. Foster, a white Republican, drew criticism when he was elected governor because his ancestors owned slaves and his grandfather rewrote Louisiana's 1898 constitution to include a grandfather clause that eliminated black voters. He said his relationships with African Americans "improved dramatically when he started taking classes at SULC."

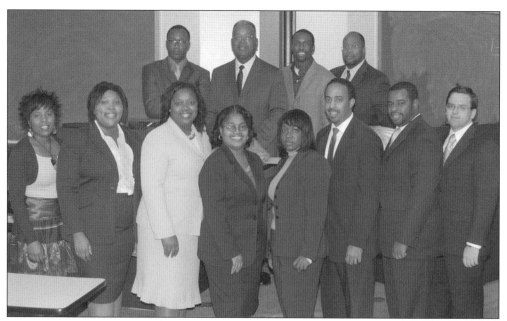

SULC celebrated the class of 2006 for its history-making 67 percent first-time bar passage rate. Several members of the class and the SULC bar preparation course team are pictured, from left to right, (first row) Kristen Pleasant, Nadine Dunbar, Christy Jones Barnes, director Cynthia N. Reed, director Regina Ramsey James, Jason Thrower, Eric Claville, and Antonio Ferachi; (second row) Edward Moses, Chancellor Freddie Pitcher Jr., Edward "Ted" James, and course leader Shawn Vance. During academic year 2009–2010, SULC enrolled 599 students, including Jasmine Brooks, class of 2009, pictured below in conversation with Prof. Paul Race. The largest class in SULC history, 150 members, participated in the 2011 graduation. SULC achieved an 85.49 percent graduation rate and 83.33 percent student retention rate during this period.

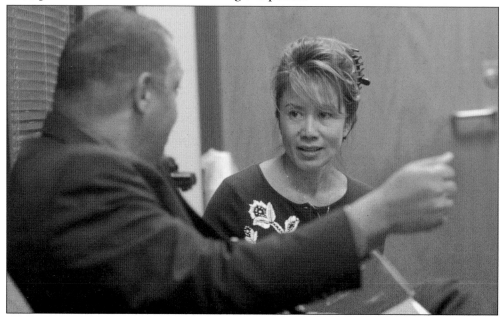

An advertisement, like this one, was purchased for placement in select newspapers throughout Louisiana publicizing the part-time evening program. Students featured are among the firsts who enrolled in the part-time evening program in 2004, and all earned a JD.

97

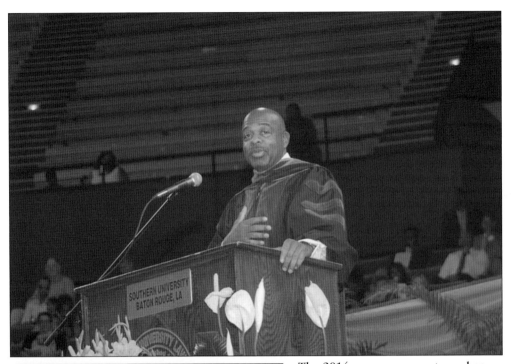

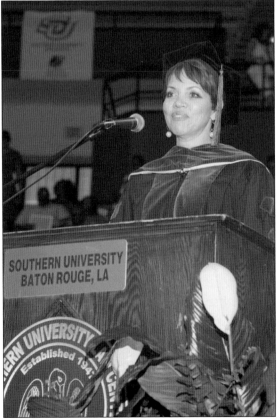

The 2014 commencement speaker was Judge James E. Graves Jr., of the US Fifth Circuit Court of Appeals, the first African American from Mississippi and the third African American to serve on the Fifth Circuit Court bench. Judge Graves praised SULC's legacy of service and preparing leaders. "Roots that are planted here (SULC) make you a part of that legacy of service," and prepare you to lead, he said. SULC alumni leaders who were featured commencement speakers have included Chief Judge Brian Jackson, class of 1985, of the US District Court for the Middle District of Louisiana; US Attorney Stephanie Finley for the Western District of Louisiana, class of 1991; SU Board member Antonio "Tony" Clayton, class of 1990; and Louisiana state senator Melvin "Kip" Holden, class of 1985. Claire Babineaux-Fontenot, class of 1989, executive vice president and treasurer of Walmart Stores, Inc., (at left) is pictured addressing the 2015 graduating class.

During the 2015–2016 academic year, Patrick Harrington of Benton, Louisiana, was elected the first white SBA president at Southern, co-chair of the Diversity Committee, and was a student member of the Louisiana Board of Regents. "It was a great honor—but in doing so—I did it by building relationships and getting to know and respect and understand all groups of people," Harrington said of his SBA election. Pictured above, from left to right, are Harrington, Chancellor John K. Pierre, Vice Chancellor Roederick White (student affairs), Diversity Committee co-chair Cassandre Michele, and Vice Chancellor Russell L. Jones (academic affairs).

Brittany Tassin (right), class of 2016, was one of five students nationwide recognized as a "Law Student of the Year" in the 2016 spring issue of the *National Jurist Magazine*. Tassin's activities on campus and in the community included pro bono coordinator, member of the recruitment committee, charter member of the Trial Advocacy Board, student-attorney in the Juvenile Law Clinic, and intern and volunteer hotline advocate for Sexual Trauma and Awareness Response organization (STAR).

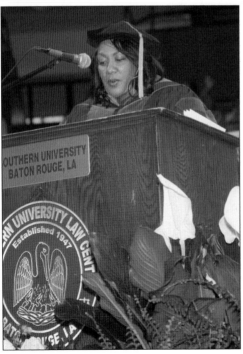

Judge Shonda D. Stone, class of 1988, of the Second Circuit Court of Appeal in Shreveport, Louisiana, addressed the 135-member class of 2017 at the SULC commencement. Judge Stone is the daughter of the late Dr. Jesse N. Stone. When elected to the Second Circuit Court on March 5, 2016, she became a part of history as a daughter and father serving as appellate court judges. Judge Stone formerly served as a judge in the Caddo Parish Juvenile Court, elected in 2009 after practicing law for 15 years in her hometown. She is a member of the Board of Governors for the Louisiana Judicial College and the Judicial Budgetary Control Board. The 2017 graduating class included the great-grandson of the late LSU Law Center dean Paul M. Hebert. Pictured above from left to right are outgoing SBA president Jordan Franklin; top student for the day division Erin A. Hammons, Chancellor John Pierre; Judge Stone; and top student for the evening division Crystal M. Etue.

Five

YIELDING PRACTICE-READY LAWYERS
FACULTY AND ACADEMIC PROGRAMS/SERVICES

The Seriousness of Purpose statement printed in the 1974–1975 law school bulletin declared the following: "There is a presumption that every student entering the school enters it with a seriousness of purpose insofar as his class attendance, preparation, and participation in the academic life . . . is concerned. Any student who enters . . . without that seriousness of purpose, or fails to maintain it after entering, will be dropped from the student body upon proper and due proceedings." (Courtesy of the A.A. Lenoir family.)

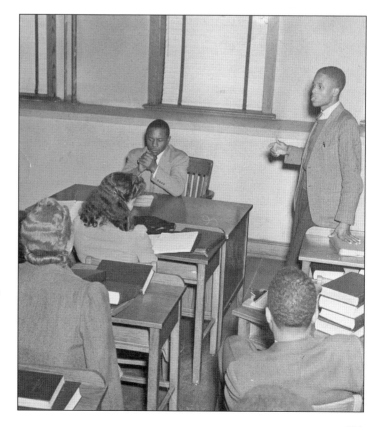

Community involvement provided Dean A.A. Lenoir with valuable contact with Southern supporters and potential law students. The dean (above) chauffeurs student participants in the Bayou Boys and Girls State annual parade in Scotlandville. The law school and the SU political science department hosted summer sessions in leadership and citizenship for this statewide organization and its co-ed group. In the process, many students became more familiar with higher education in general and SU in particular and were eager SU recruits. Lenoir, his wife, Estella, (below, from left to right) and other SU supporters were members of the American Legion and its auxiliary that sponsored the Bayou Boys and Girls State program. Lenoir also served on the Southern Teachers and Parents Credit Union board and as commissioner on the Louisiana State Labor Board.

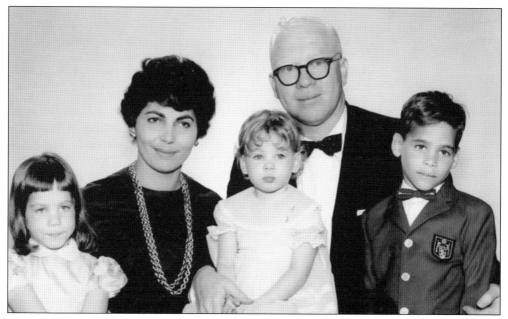

During his 21 years at Southern, Prof. Edward L. Patterson was an integral part of the life of the institution, as was his family. His daughter, attorney Bonnie C. Cannon, recalls that faculty and students were regularly invited to their home in the Southern Heights subdivision. "There were discussions of civil rights and other issues of the day, as well as personal conversations about families and friends," she said. Pictured with Patterson are, from left to right, Bonnie, Catherine A. Lewis, Lori A. Saizan Patterson, and Edward L. Patterson III. (Courtesy of Bonnie C. Patterson Cannon.)

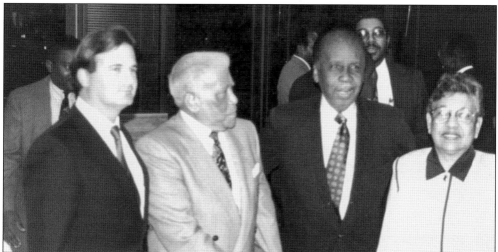

During the 1972 campus unrest that resulted in the deaths of students Denver Smith and Leonard D. Brown, law students were taking their finals to be eligible to sit for the February (1973) bar exam. National guardsmen were stationed around the campus, including in the classroom where Dean Berry was administering a final exam. When armed students entered the classroom, Berry successfully urged them to retreat, and the law students were able to complete their finals. Pictured from left to right are Judge Angelo Piazza, Justice Revius Oritique, Dean Berry, and Miriam Oritique. (Courtesy of Judge Angelo J. Piazza III.)

The Student Bar Association was instituted at SULC during the 1949–1950 school year. Plaques with the names of SBA presidents since the initial election are displayed near the association's office located on the first floor of the West Wing of A.A. Lenoir Hall. Included on the plaques are the names of Monica Azare (1993–1994) and Terry C. Landry Jr. (2006–2007). Azare, pictured left, the third female SBA president at SULC, succeeding Jo Ann Gines (1982–1983) and Catherine Woods (1988–1989), is senior vice president of corporate communications for Verizon Communications. The Louisiana native and New York resident was inducted into the SULC Hall of Fame in 2013. Landry, pictured below, and his wife, Valencia Vessel Landry, class of 2007, established Landry & Vessel, LLC, Plaquemine, Louisiana, in 2010. A legacy graduate, Landry has a cousin Judge Lori A. Landry, class of 1989, of the 16th Judicial District Court, St. Martinville, Louisiana.

Beginning in the 1948–1949 school year, the J.S. Clark Memorial Award, valued at $50, was awarded to the student who maintained the highest scholastic average at the end of the freshman year. The award was in memory of Dr. Joseph S. Clark, right, SU president emeritus at the time of his death. A student loan fund was established in the 1963–1964 school year courtesy of the Louis A. Martinet Legal Society founded in 1957 by A.P. Tureaud (below) and other black lawyers who, because of segregation, could not participate in all of the Louisiana State Bar Association activities. Financial support for students solicited by law school administrators has increased to 44 scholarships for need-based and academic achievement, as well as support for bar review, travel, debt reduction after law school, specific areas of legal study and internships, writing competitions, and more. (Right, courtesy of Southern University Archives/John B. Cade Library.)

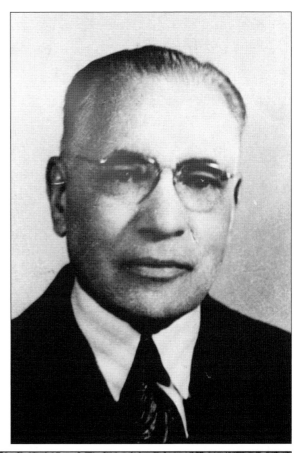

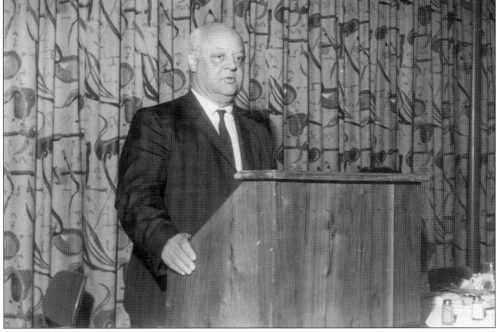

The Blackstone Society, a law interest group composed of undergraduate students, was formed at Southern during the mid-1950s to stimulate a desire in those eligible to consider careers in the legal profession. Pictured are society members Mildred Byrd (seventh from left) and Clyde C. Tidwell (far right), who later enrolled in Southern's law school. In 1956, recruitment trips were made to Grambling College, Wiley College, Bishop College, Jarvis Christian College, and Xavier University. Continuing recruitment efforts have increased to more than 14 trips each year to more than 35 universities across Louisiana and surrounding states and annual on-campus events, as the one pictured below, coordinated by the Office of Admissions and Recruitment.

Dean Lenoir stepped down as dean in 1970, and Vanue Lacour became the school's second dean, followed by Jesse Stone and Louis Berry, whose tenures encompassed the first half of the 1970s. Each made their own mark with the faculty they hired, academic programs they created or strengthened, the featured speakers they brought to the campus, and legal issues that they focused on during their time at the helm. Aaron Harris (at right), class of 1971, of St. Landry Parish served as associate dean of law from 1974 to 1990. Dean Harris admonished law students, "It is not how long you hold a book, but what you get from it while holding it." The US Army veteran, cattle rancher, farmer, and real estate developer formerly practiced law with his son Judge Alonzo Harris, class of 1986. Washington Marshall, class of 1971, joined the faculty in 1975.

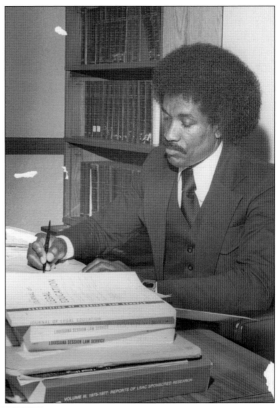

Interim Chancellor Marshall is pictured at left with 2002 commencement speaker US Representative Albert Wynn of Maryland. The US Navy veteran was formerly an attorney for the Office of the General Counsel, for the Federal Aviation Administration and for the EEOC. Other faculty members added during the 1970s included Carey DeBessonet, Saul Livitinoff, Cynthia Picou (first white female faculty member), William Mayfield, Milton C. Osbourne Jr., and Winston Riddick.

SULC's Clinical Education Program was launched in 1975 under the direction of Louis Westerfield (at left), who served until 1978. When clerkship opportunities were limited for SULC students, the Louisiana Supreme Court's Rule XX Limited Participation of Law Students in Trial Work bridged an experiential learning gap for the students and has continued to add value to the legal education program. The clinic's first director made history in 1994 as the first black law dean at the University of Mississippi, a position he held until his death in 1996. Students (pictured below) become practice-ready through clinical education in public interest internship endeavors. SULC clinics address such areas of the law as criminal, administrative/civil, juvenile, elder, tax, divorce/domestic violence, bankruptcy, and mediation. Other directors have included Julius X. Johnson, Pinkie Wilkerson, Russell L. Jones, Arthur Stallworth, Joy Clemons, Donald North, and Virginia Listach. (Left, photograph by Harold Baquet, courtesy of Loyola University New Orleans.)

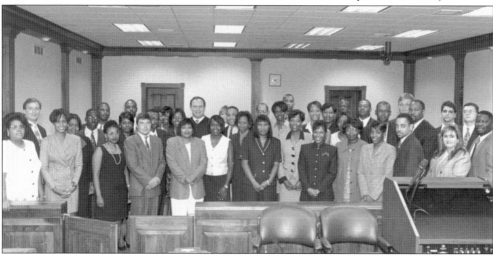

Pictured at right, Thelma Quince (Colbert), class of 1975, initiated the establishment of the *Southern University Law Review* in 1974–1975 as the publication's first editor-in-chief. Colbert's article in Vol. 1, No. 2 was titled "Dedication: in Memory of Dean Aguinaldo Alphonse Lenoir." Early law review staff are pictured below. From left to right are (first row) faculty adviser professor Donald Tate, Ethel A. Simms, Jerry Shropshire, Annette Callagain, and Moses Williams (editor-in-chief); (second row) Benjamin Cannon, Robert E. Hill, La'verne Denise Wiley, Clifford Leon Lee II, and Cleveland Coon (executive editor). Coon stated, "When I reflect on these years and these individuals, esprit de corps comes to mind. What is esprit de corps? . . . For me, law review was the embodiment of that 'Seriousness of Purpose' . . . Additionally, there was an esprit de corps we carried with us daily."

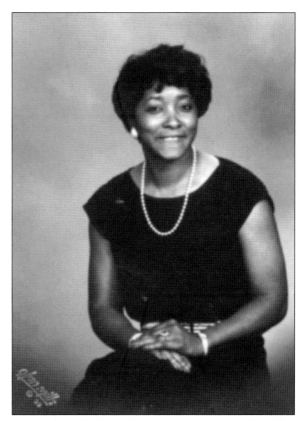

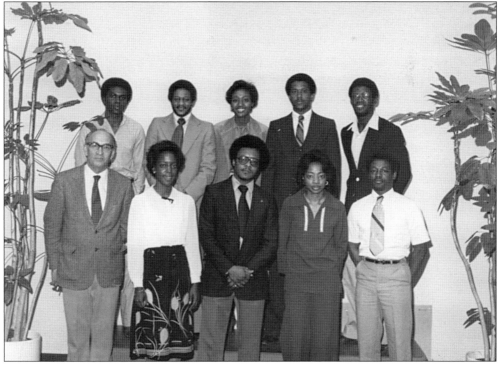

Representing 30 law schools from across the country, Canada, and Puerto Rico, more than 300 conferees visited Baton Rouge for the 2009 National Conference of Law Reviews (NCLR), hosted by the *Southern University Law Review* and coordinated by Keith Cantrelle, NCLR editor. SULC is the first historically black law school to host this conference, where attendees heard how publishing law journals affect legal opinions of the US judiciary. Chief Justice Catherine "Kitty" Kimball of the Louisiana Supreme Court, Judge Carl E. Stewart of the US Fifth Circuit Court of Appeals, and Harvard Law School professor Charles J. Ogletree (at left) were among conference speakers. In addition to keynote addresses by CNN's senior political analyst Jeffrey Toobin and *Black's Law Dictionary* editor-in-chief Bryan A. Garner, conference participants chose from more than 35 panel discussions and seminars. Pictured from left to right are Judge Stewart, Toobin, and Chancellor Pitcher.

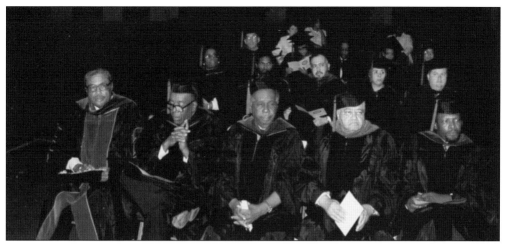

Faculty members who joined in the 1980s are included in this photograph, from left to right, (first row) Jesse N. Stone, Leroy White, Louis Berry, William Mayfield, and Cleveland Coon; (second row) Judge Joan Bernard Armstrong, Russell Jones, Steve Barbre, V. Elaine B. Patin, Ernest Easterly; (third row) Donald Tate, unidentified, Clyde Tidwell, Alfreda Diamond, and unidentified. Other faculty who joined in the 1980s not pictured included Jose Cortina, William Dauphin, Charles Donegan, Henry Jones, Eddie Jordan Jr., Audrey LeBlanc, Gail Ray, former Louisiana Supreme Court justice Joe Sanders, and Pinkie Wilkerson. New lecturers of law were Robert Collins, Robert Jennings, US federal judge Frank Polozola, and Wesley Steen.

Alfreda Diamond (left) was named vice chancellor for institutional accountability and the evening division in 2017. The former state judicial law clerk's research focuses on equal educational opportunities for African Americans, children, and the disabled.

Stanley A. Halpin Jr. began his SULC teaching career in 1990, with an extensive background in public interest law, handling major cases that ended racially discriminatory methods of election, established single-member district preference in court-drawn electoral plans, invalidated a discriminatory parade law used against civil rights marchers, and enjoined the use of the Confederate flag in public schools. As the SULC Speakers Series Committee chairman, Halpin (pictured above, third from left) secured national speakers on civil and human rights and public interest law, such as those shown in this photograph. Judith Perhay (pictured below on the right with colleagues Olivette Mencer and Roederick White) has been a full-time faculty member since 1993. The former federal judicial law clerk's research areas have been environmental law and construction law. Other faculty members who joined in the 1990s include Michelle Ghetti, Dorothy Jackson, Virginia Listach, Jacqueline Nash, Donald North, Arthur Stallworth, and Alvin Washington.

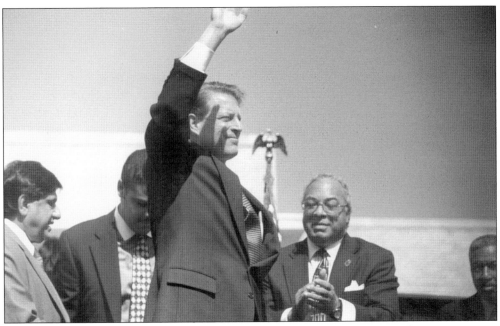

Vice Pres. Al Gore acknowledged during the SULC 50th anniversary opening ceremony, "It is a time to reflect on the heritage of this institution, which has done so much to expand opportunity and justice—here in Louisiana and all across America. As you have shown here at the Southern University Law Center, the greatest building block for the future is education." The 1997 fete included a judicial summit, civil rights summit, and a legislative summit. Speakers reiterated that over the last 50 years the law center had been "molding thousands of minds to be leaders in the community." Pictured below, from left to right, Joel W. Motley Jr.; Judge Constance Baker Motley; Etta Kay Hearn, class of 1969; and Judge Calvin Botley celebrated with the law center family. Judges Motley and Botley were speakers for the judicial summit.

After Chancellor B.K. Agnihotri resigned/retired as head of SULC in 2001 he became global ambassador at-large and adviser to the United States. The fruits of his labor at SULC set the groundwork for quality faculty, staff, academic programs, and student services, all revealed in the law center's successful model of diversity. Agnihotri is pictured standing in second row at left with other administrators, faculty, and student members of the *Southern University Law Review*. Faculty members engaged in research and publishing have increased thanks to the Louisiana Public Facilities Authority and others that provided incentive funding in the form of summer research stipends for faculty beginning in 2004. Endowed professorships also provide additional financial support and prestige to the faculty. Pictured below, from left to right, are endowment donor James Noland; Horatio C. Thompson Endowed Professor Evelyn L. Wilson; and Baton Rouge businessman Horatio Thompson.

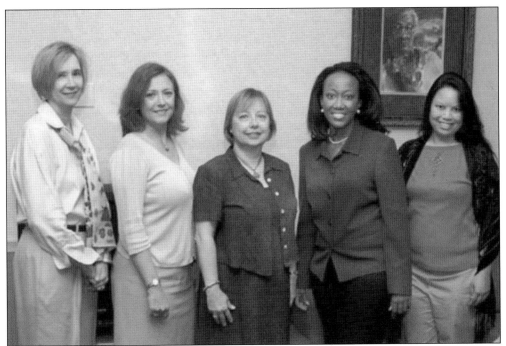

In 2004, SULC welcomed professors (above, pictured from left to right) Linda Fowler, Nadia Nedzel, Gail Stephenson, Shenequa Grey, and Ruby Andrew. Andrew, an expert in legislation and intellectual property, has been a congressional policy analyst. Fowler came to SULC from LSU, where she directed the appellate-advocacy program. Grey previously worked as a staff attorney for the American Prosecutor's Research Institute and as an assistant district attorney. Her research focuses on Fourth Amendment search and seizure. The scholarship of Nedzel, a former international trade attorney and federal judicial clerk, focuses on the rule of law. Stephenson, director of legal analysis and writing, was administrative general counsel for a state appellate court. Her research interests include Louisiana appellate procedure and the state's civil law tradition.

Angela A. Allen-Bell (right) joined the faculty in 2008 as an expert in appellate law, with research interests in social, restorative, or criminal justice; and constitutional, civil, or human rights issues. (Photograph by Pamela Labbe, courtesy of the Baton Rouge Bar Association.)

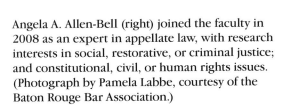

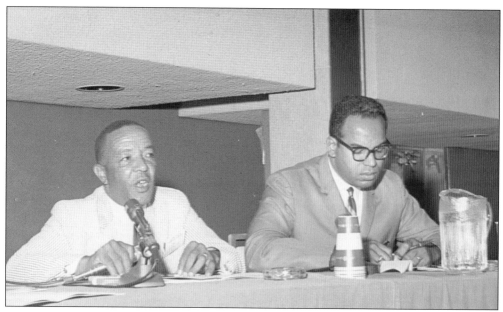

SULC's excellent education environment is supported by academic programs and services geared to the needs of all students, as well as the contributions of faculty members through teaching, scholarly research, and service in leadership roles in the Academy and professional legal organizations. Faculty members have served as Fulbright scholars, a US Supreme Court Fellow, and local and specialty bar officers and have been honored by the local and state bar associations. Throughout the history of the institution, they have invested in student success and produced lawyer-leaders. Dean A.A. Lenoir is pictured above with law instructor Robert Collins. Pictured below are faculty members attending the 2008 commencement, from left to right, (first row, sitting) Christian Fasullo, Linda Fowler, Michelle Ghetti, Gail Stephenson, Chancellor Freddie Pitcher Jr., Vice Chancellor Arthur Stallworth, Virginia Listach, Maurice Franks, Okechukwu Oko, and Vice Chancellor Russell Jones; (second row, standing) Donald Tibbs, Stanley Halpin, Evelyn Wilson, Paul Race, Vice Chancellor John Pierre, Shawn Vance, Winston Riddick, Washington Marshall, Ernest Easterly, and Prentice White.

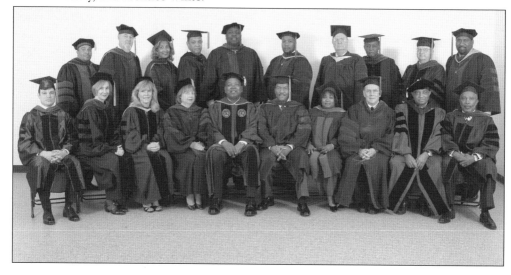

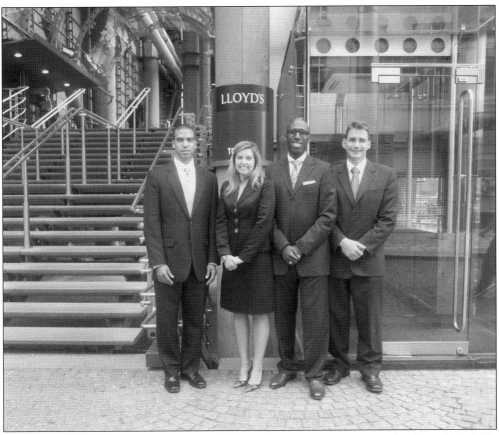

Special programs that increase knowledge of career prospects and of specific skills enhance the educational experiences of students at SULC. The Summer Abroad Program in London (above) was launched in 2005; Prof. Maurice Franks was program director. The Trial Advocacy Board (below) was established in 2016 to offer select students opportunities to sharpen their trial advocacy skills. Prof. Shenequa Grey (sitting at center) is board adviser.

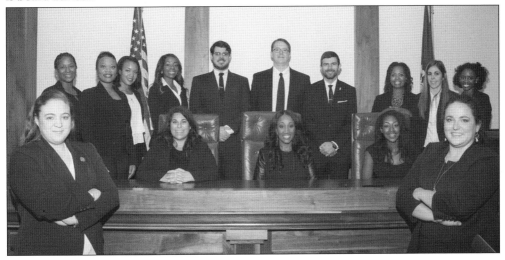

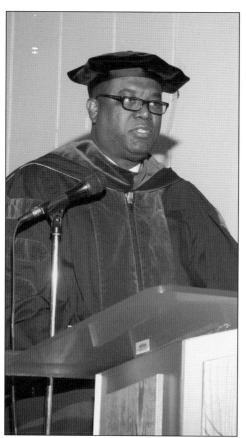

Fall 2009 graduates of SULC were recognized for the first time in a hooding ceremony on January 15, 2010. Since the opening of the part-time day program in 2000 and part-time evening division in 2004, an increasing number of students have completed graduation requirements following the summer and fall semesters, becoming eligible to take the bar examination in February prior to the annual SULC spring commencement. This special hooding ceremony does not take the place of commencement. All graduates continue to have their degrees conferred at spring commencement. Speakers for the hooding ceremony, like those for commencement, are selected from among the nation's foremost members of the legal community, who give timely and inspiring addresses to the graduating classes. Speakers for the hooding ceremonies have included alumni such as Judge Janice Clark, Domoine Rutledge (at left), and Shelton Dennis Blunt. Pictured below at the 2015 ceremony are, from left to right, Chancellor Freddie Pitcher Jr.; speaker Debra Page Coleman, class of 1988; Adj. Prof. Tim Hardy; and Vice Chancellor Roederick White.

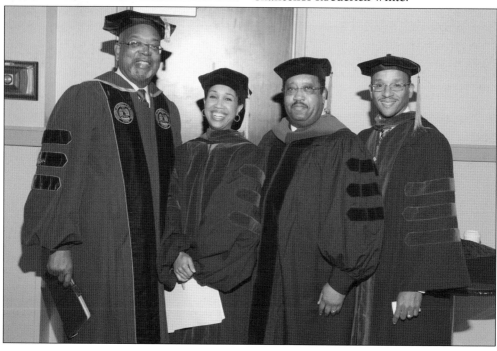

Six

ALUMNI HONORS
DIVERSITY AND PUBLIC SERVICE

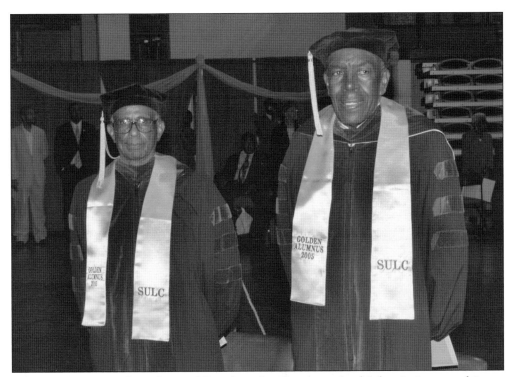

SULC graduates, as these first golden alumni to be recognized Johnnie Jones and Leroy White, have been trailblazers in the legal profession. Members in each SULC graduating class are becoming firsts and one step at a time achieving some measure of equality, civil rights, and justice. Annual recognition of alumni achievements tells the colorful story of SULC's contributions to the betterment of society.

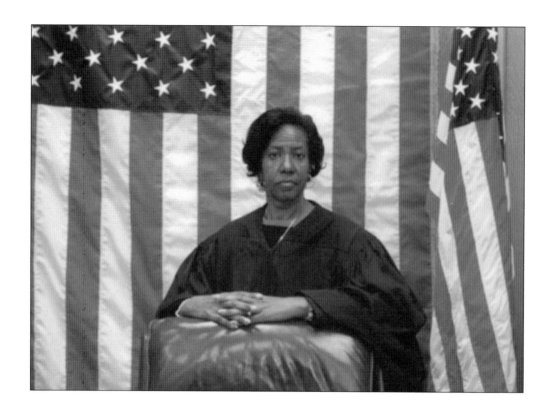

Judge Janice Clark, class of 1976, lead plaintiff in the 1986 *Clark v. Edwards* lawsuit, helped expand the number of black judges in Louisiana to the country's most per capita. In a settlement by Gov. Edwin Edwards, the expansion was accomplished with the addition of judicial sub-districts in majority black areas. Other alumni plaintiffs were Orscini Beard, Eddie Crawford, and Norbert Rayford. SULC remembered *Clark* and *Chisom v. Edwards* that addressed the election of Louisiana Supreme Court justices 30 years later. Pictured from left to right are Ernest Johnson, class of 1976, *Clark's* lead attorney; interim chancellor John Pierre; Louisiana attorney general Jeff Landry; Arthur Thomas, class of 1976; former governor Edwin Edwards; SU president-chancellor Ray Belton; Judge Yvette Alexander; Clark; Judge Freddie Pitcher Jr. (ret.), class of 1973; Judge John M. Guidry, class of 1989; Judge Pamela Taylor-Johnson, class of 1979; and former Louisiana attorney general Richard Ieyoub, who was also involved in the settlements.

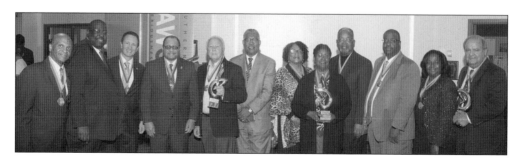

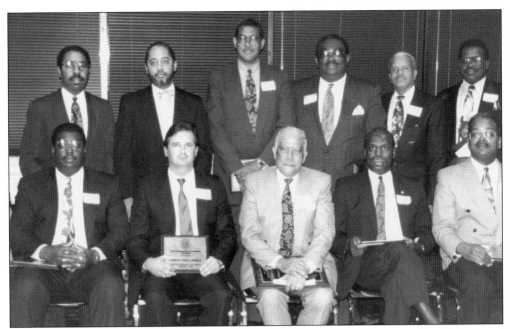

Alumni judges were honored at SULC's 50th anniversary (above). Since 2003, the annual alumni round-up has taken alumni honors to the next level. Pictured below are the first Hall of Fame inductees, from left to right, (sitting) Johnnie A. Jones Sr., Louisiana senator Charles D. Jones, Etta K. Hearn, Walter C. Dumas, and Murphy W. Bell Sr.; (standing) Carl Franklin for the late Jesse N. Stone; Jelynne LeBlanc Burley for the late Audrey LeBlanc; Eugene C. Cicardo Jr., for the late Eugene C. Cicardo Sr.; Clyde Tidwell; Chancellor Freddie Pitcher Jr., and Justice Revius O. Ortique Jr. (ret.). Eighty-five alumni have been inducted between 2003 and 2017. In 2009, SULC began recognizing distinguished alumni within the first 10 years of their careers. Thirty-six distinguished alumni have been honored in alumni round-ups from 2009 to 2017. (Above, courtesy of Judge Angelo J. Piazza III.)

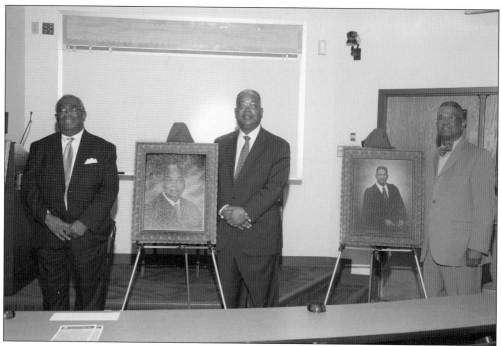

SULC formally installed its Alumni Judicial Wall of Fame in 2011. First-time portrait unveilings for this tribute featured Judge Judi Abrusley, class of 1996; Judge Alvin Batiste, class of 1981; Judge Herbert Cade, class of 1976; Judge Curtis L. Calloway (ret.), class of 1965; Judge John Robin Free, class of 1989; (above, from left to right) US Magistrate Judge Louis Moore Jr., class of 1972; Judge Freddie Pitcher, Jr. (ret.), class of 1973; and Judge Wayne Salvant, class of 1974. In 2017, the judicial wall featured 52 portraits.

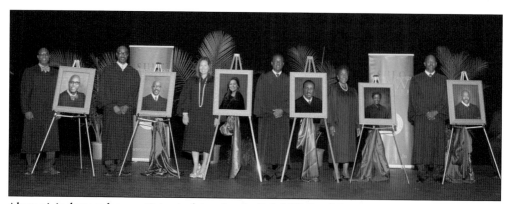

Alumni judges who participated in the Judicial Wall of Fame ceremony in 2016 are pictured, from left to right: Judge E. Adrian Adams, class of 1992; Judge Lee V. Faulkner, class of 1991; Judge Erin Waddell Garrett, class of 2006; Judge Marc E. Johnson, class of 1989; Judge Ethel Simms Julien, class of 1982, and Judge Tarvald Smith, class of 1995.

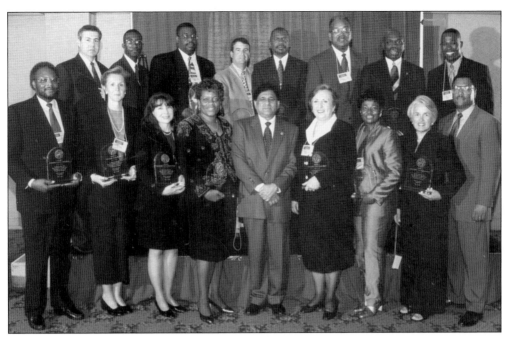

preLaw Magazine placed SULC on its honor roll for alumni employed in government service. In "Best Schools for Public Service," SULC was in the top 20 (No. 19) for government service based on "curriculum," including externships in government service, and "employment," based on the percentage of grads who are employed in public service. SULC was one of only two schools earning an A+ rating in public service employment. Baton Rouge area alumni judges and elected officials recognized by the law center for their public service in 1999 are pictured above. Pictured below are, from left to right, Judge Leon L. Emanuel III swearing in his sister Judge Ramona L. Emanuel, the first female elected to the 1st Judicial District Court in Shreveport, Louisiana, as their parents Leon L. Emanuel and Otis Emanuel stand with them. Before Judge Leon Emanuel's retirement from the bench in 2015, the Emanuel siblings shared an office suite in the 1st Judicial District Courthouse. (Below, courtesy of the Emanuel family.)

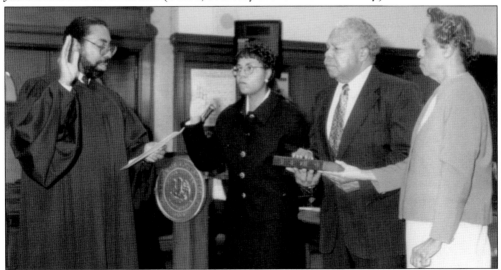

Marcus Augustine, class of 2009, served as judicial clerk for Judge Carl E. Stewart of the Fifth Circuit Court of Appeals. Augustine, the first SULC graduate to clerk for the judge, is pictured above with Judge Stewart during a celebration of the conclusion of his one-year tenure of service. Augustine is now counsel for Cleco in Alexandria, Louisiana. Alejandro "Al" Perkins, class of 2004, partner at Hammonds, Sills, Adkins & Guice, LLP, was sworn in January 2017 as chairman of the University of Louisiana System Board of Supervisors. The Prairieville resident was appointed to represent the 6th Congressional District on the Board by Gov. John Bel Edwards. He joins a number of alumni serving on Louisiana higher education boards including Tim Hardy, class of 1981; Antonio "Tony" Clayton, class of 1990; Domoine Rutledge, class of 1997; Patrick D. Magee, class of 2004. (Above, courtesy of Chief Judge Carl E. Stewart of the Fifth Circuit Court of Appeals; left, courtesy of Hammonds and Sills, LLP.)

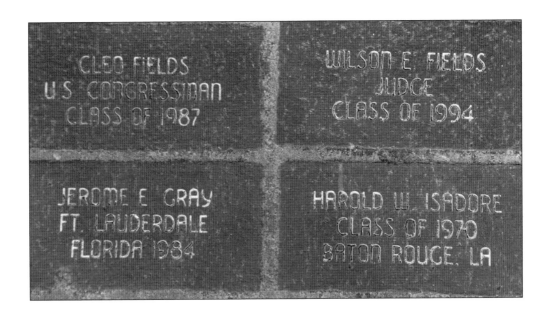

The history of Southern University Law Center's contributions to society, the bar, and the judiciary continues to be written. From the perspective of tradition, SULC serves as one of the great law schools within the corpus of the Historically Black Colleges and Universities of the United States. SULC's background in civil rights work and quest for equality is significant and the institution will not give up on such goals. Through the SULC Brick Legacy Campaign, donors can create a lasting tribute with names etched in the bricks of the walkway leading to the front doors of A.A. Lenoir Hall as they provide financial support to the mission of the law center. Pictured below at the November 2016 ribbon-cutting ceremony are some of the first donors to participate in the campaign. Bricks, bearing the names of several of the alumni and friends, are shown above.

BIBLIOGRAPHY

Emanuel, Rachel L. *Taking a Seat for Justice: The 1960 Baton Rouge Sit-ins*. Baton Rouge, LA: Louisiana Endowment for the Humanities, 1996.

————. The Bridge Builder: Dr. Jesse Nealand Stone Jr. Baton Rouge, LA: Southern University Law Center, 2001.

————, and Alexander P. Tureaud Jr. *A More Noble Cause: A.P. Tureaud and the Struggle for Civil Rights in Louisiana*. Baton Rouge, LA: Louisiana State University Press, 2011.

Hargrave, W. Lee. *LSU Law: The Louisiana State University Law School from 1906 to 1977*. Baton Rouge, LA: Louisiana State University Press, 2004.

Jones, Russell L. "African-American Legal Pioneers: A Biography of Vanue B. Lacour 'A Social Engineer.'" *Southern University Law Review* Vol. 23, No. 63 (Fall, 1995), p. 72.

Marcus, Frances Frank. "Social Issues: The Invisible Black University." *New York Times*, April 14, 1985.

Raffel, Jeffrey A. "Historical Dictionary of School Segregation and Desegregation." *Journal for the Study of the American Experience*, 1998.

"Felton G. Clark, Negro Educator." *New York Times*, 6 Jul. 1970.

"Dr. Felton G. Clark Centennial." *The Southern Digest*, 10 Oct. 2003.

Vincent, Charles. *A Centennial History of Southern University and A&M College 1880–1980*. Baton Rouge, LA: Moran Press, 1981.

Wilson, Evelyn L. *Laws, Customs and Rights: Charles Hatfield and His Family, a Louisiana History*. Westminster, MD: Willow Bend Books, 2004.

————, and Katherine Tonnas. "From the Historical Perspective: Access to Justice; Charles J. Hatfield." *Louisiana Bar Journal* Vol. 50, No. 2 (August–September, 2002), pp. 114–118.

INDEX

DISCOVER THOUSANDS OF LOCAL HISTORY BOOKS FEATURING MILLIONS OF VINTAGE IMAGES

Arcadia Publishing, the leading local history publisher in the United States, is committed to making history accessible and meaningful through publishing books that celebrate and preserve the heritage of America's people and places.

Find more books like this at
www.arcadiapublishing.com

Search for your hometown history, your old stomping grounds, and even your favorite sports team.